MW01078337

IMAGES
of America

WYOMING'S
HISTORIC RANCHES

ON THE COVER: Joseph E. Stimson took this photograph of Tweed's Ranch, at the head of Beaver Creek near Lander, Wyoming, in 1903. Wyoming's best-known photographer, Stimson arrived in Cheyenne in 1889 and began his career as a portrait photographer. His work spanned almost 60 years, and his Wyoming subjects included agriculture, towns and cities, the Union Pacific Railroad, and industry. (Courtesy of the J.E. Stimson Collection, Wyoming State Archives, Department of State Parks and Cultural Resources.)

IMAGES
of America

WYOMING'S HISTORIC RANCHES

Nancy Weidel, Wyoming Department
of State Parks and Cultural Resources

ARCADIA
PUBLISHING

Copyright © 2014 by Nancy Weidel, Wyoming Department of State Parks and
 Cultural Resources
ISBN 978-1-4671-3149-0

Published by Arcadia Publishing
Charleston, South Carolina

Printed in the United States of America

Library of Congress Control Number: 2014941058

For all general information, please contact Arcadia Publishing:
Telephone 843-853-2070
Fax 843-853-0044
E-mail sales@arcadiapublishing.com
For customer service and orders:
Toll-Free 1-888-313-2665

Visit us on the Internet at www.arcadiapublishing.com

*Dedicated to all of Wyoming's hardworking ranchers and their
families, who helped create and sustain a uniquely western
lifestyle that has endured through many generations*

CONTENTS

ACKNOWLEDGMENTS

I wish to acknowledge photographer Richard Collier for his wonderful images and innumerable contributions to this book. And thank you to Milward Simpson, director of Wyoming State Parks and Cultural Resources, for allowing me the time needed to produce this book. Thanks to Rhonda Brandt of the US Department of Agriculture, National Agricultural Statistics Service (NASS) for interpretation of the 2012 Wyoming statistics. I would especially like to thank Jeff Reutsche and Stacia Bannerman of Arcadia Publishing for their incredible patience and understanding.

The images in this volume appear courtesy of the Wyoming State Archives (ARC), Department of State Parks and Cultural Resources; the State Historic Preservation Office (SHPO), Department of State Parks and Cultural Resources; Richard Collier (RC); the Wyoming State Museum (WSM); the American Heritage Center Photograph Collection (AHC); the University of Wyoming, including the Emmett D. Chisum Special Collection (EDC); the Trail End Historic Site (TE), Sheridan County Historical Society; the Wyoming Stock Growers Association (WSGA); and Mark Miller (MM.)

INTRODUCTION

The history of ranching in Wyoming is not only a state history; it is also an important chapter in western history. Perhaps more than any other state, Wyoming has become synonymous with ranching, and the image of a cowboy on a bucking horse symbolizes one aspect of its rich history. That image can be seen everywhere in the state, from the license plate to the state quarter, and it is the trademarked logo of the University of Wyoming, whose athletic teams are referred to as the Cowboys and Cowgirls.

An image does not always match reality, and today's tourist visiting Wyoming for the first time may be disappointed by not seeing a cowboy on every street corner, but they are still out there, as are the state's 7,360 ranches, as well as the 1.57 million cows counted in the 2012 US Department of Agriculture's statistics. Wyoming has the largest average-sized ranches in the country at 2,586 acres. Most of them cannot be seen from the major and secondary roads; often one must travel 10 miles on gravel or dirt roads to glimpse one off in the distance. And what you can see is usually not a movie-set ranch that more often resembles a fancy dude ranch. A real Wyoming ranch is a working ranch, often one that has been in the same family for many generations. The history of each ranch is the history of the people who ranched there.

Beginning in the 1820s, the state of Wyoming was only a part of the vast area that became known on maps as the Great American Desert, hundreds of square miles on either side of the Oregon Trail; for most people, a place to pass through but not settle. This impression began to change in the late 1850s and early 1860s as men realized that the native mixed grasses could support, as they had for centuries, herds of grazing animals through both summer and winter. The northern ranges became stocked in the 20 years that followed the Civil War as many Texas ranchers, cut off from eastern and southern markets during the conflict, trailed their multiplying cattle herds off the overgrazed southwestern land to the open range of Wyoming and Montana Territories. The availability of the "free" grazing land of the unclaimed public domain—consisting of thousands of square miles—combined with the rapid access to eastern livestock markets provided by the 1869 completion of the first transcontinental railroad, made the northern range a beacon for many individuals as well as investors.

Men made fortunes in the cattle business during the open range era, which lasted only a short period of time before it collapsed in the winter of 1886–1887, a winter that remains famous in western ranching history. By the early 1880s, the range had become overstocked, although thousands of cows continued to pour onto the northern range. One expert from this time estimated there were two million cattle in Wyoming in 1885, although an 1884 report to the Department of the Interior from the territorial governor varied quite a bit from that number and enumerated only 750,000 cows. During the open range era, very few ranchers supplied winter feed for their cattle; instead, they depended upon the ability of the range to nourish the cows year-round. In addition to the overstocked range, a particularly dry 1886 summer followed by an early, wet, and bitterly cold fall and winter led to the death of thousands of starving animals unable to dig through the

ice-covered snow to reach the grass underneath. Depending on the county location, some ranchers lost most of their herd, while one later historian surmised that overall, cattle numbers decreased by 15 percent. An exact number of the suffering animals lost will never be known, as the open range cow census, called "book count," was at best only an estimate. The open range system was basically gone by the 1890s, but its history became the legend that lives on today.

Not all cattle and sheep ranches established during the open range period were large spreads. Other people of more modest means filed on homesteads where they hoped to make a new life for themselves and their families. By 1877, three Congressional acts, the 1862 Homestead Act, the 1873 Timber Culture Act, and the 1877 Desert Land Act, with various fees and provisions, allowed a homesteader to claim 840 acres. Through these acts, the national government encouraged the settlement of the public domain by the American ideal of the independent farmer who owned his own land, an idea promoted by Thomas Jefferson. Thousands of people attempted to pursue that dream and flocked to Wyoming during the first three decades of the 20th century.

Settlement in many parts of Wyoming would have remained sparse had it not been for irrigation, which was the primary objective of the 1877 Desert Land Act. Water rights were essential and ownership varied by state, but in Wyoming, the state owned them. Individuals could claim first, second, third, and later rights depending upon the date they settled, the earlier the better. The national government, along with many would-be farmers who attempted to cultivate crops in the driest areas, discovered, often too late, that the land was better suited to livestock grazing than crop production. A single cow and her calf (or the equivalent of five sheep) on a Wyoming ranch required from 10 acres where the grass grew well to as many as 170 acres in places like the Red Desert. At first, commercial irrigation companies, for which settlers paid the cost, developed the essential flumes or ditches necessary to deliver water to the cultivated land. But it was the national government that facilitated irrigation on a much larger scale when it began to fund the construction of the large dams and reservoirs in the west, three of those in Wyoming in the early 1900s.

The practice of dry farming, basically the belief that rain followed the plow once a farmer broke up his dry land, was another method of cultivation promoted to prospective homesteaders in the late 19th and early 20th centuries. A concurrent increase in rain confirmed the practice for a number of years, although dissenting experts argued that the rise in precipitation was natural and unrelated to the plowing of the soil. The increase in scientific soil research conducted at this time led to new agricultural theories promoted to farmers and ranchers through publications written and distributed by the newly established extension offices of land grant universities.

Throughout the phases of Wyoming agricultural history, family ranches have been its enduring backbone. Many have remained in the same family for well over 100 years and six or seven generations. It is an amazing achievement due to the uncontrollable aspects of ranching—weather conditions, prices, feed supplies, development of the land for incompatible purposes, and other man-made and natural disasters. Family operations played a large, defining role in Wyoming's ranching history, every bit as important as the cattle barons, and will continue to do so in the future. They will help ensure that Wyoming remains "the Cowboy State."

One

THE BEEF BONANZA AND THE OPEN RANGE

Although an estimated 500,000 people crossed through what is now the state of Wyoming on the various immigrant trails, few settled. Beginning in the 1820s, maps of the west included it in the large area named the Great American Desert, considered to be a vast, uninhabitable region. The "discovery" that this desert would actually support livestock is often told in an apocryphal story that took place in the mid-1860s. When a sudden blizzard stranded oxen on Wyoming's Laramie Plains, the owner was forced to abandon them for the winter without food or shelter. Upon his return the following spring, he found his livestock surprisingly alive and well-fed by the native grasses. Wyoming's open range era had begun. (ARC.)

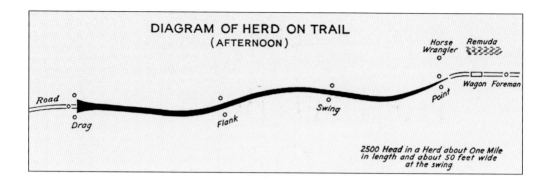

DIAGRAM OF HERD ON TRAIL
(AFTERNOON)

The end of the Civil War signaled a new era for the country, including its huge western territories. The completion of the first transcontinental railroad opened new markets in previously inaccessible areas and facilitated rapid development and settlement. The burgeoning Texas cattle industry, cut off from the East Coast during the war, flourished as the legendary trail drives to Midwestern railheads and the northern grasslands of Wyoming and Montana Territories began. The image above is a diagram of a trail herd. The photograph below shows the 1940 dedication of a Texas Trail monument near Rawhide Creek, in eastern Wyoming, which included local ranchers as well as Russell Thorp, executive director the Wyoming Stock Growers Association, shown on the left. (Both, ARC.)

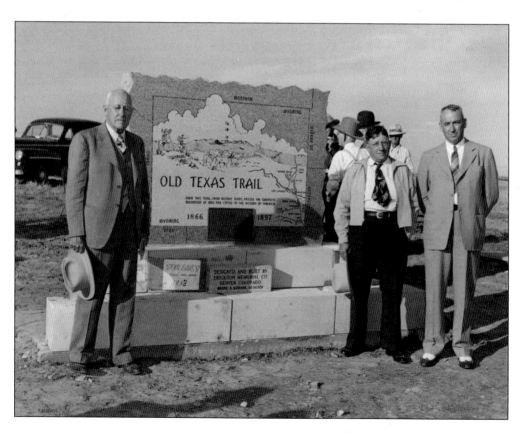

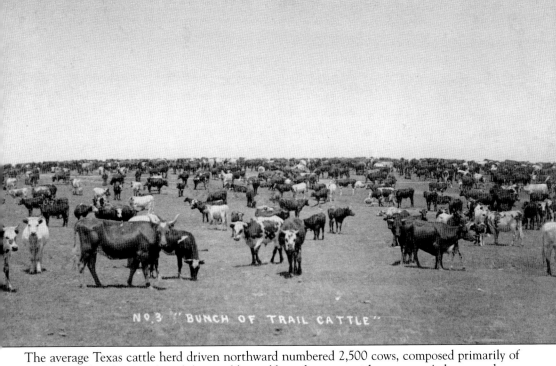

NO. 3 "BUNCH OF TRAIL CATTLE"

The average Texas cattle herd driven northward numbered 2,500 cows, composed primarily of hardy Texas longhorns, a breed that could travel long distances without water. A dozen cowboys, including a trail boss, along with 50–60 horses, four mules, and a chuck wagon (sometimes called a mess wagon) that hauled the food and bedding, accompanied the herd. Starting shortly after dawn, with a noon break, they moved about 15 miles a day. The trip could take from four to six months. Between 1870 and 1880, approximately 265,000 cows, representing countless trail drives, entered Wyoming. Not all came from Texas; cattle driven eastward from Oregon also stocked the range during this period. These herds often consisted of Hereford cows, acknowledged as a breed superior to the longhorn. (ARC.)

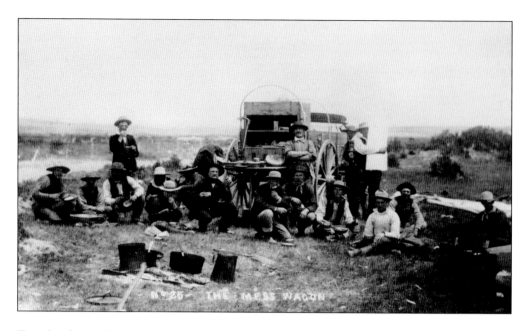

Texas longhorns, like the one in the photograph below, also met the huge demand of the government for beef rations on the large northern reservations to which most of the Plains Indians had been confined by the late 1870s. The systematic slaughter of the buffalo herds, on which the tribes had depended for food, clothing, and shelter, occurred during this period and facilitated Indian removal and ranching development. In 1880, the government purchased about 40 million pounds of beef for the reservations, equal to 50,000 cows. (Both, ARC.)

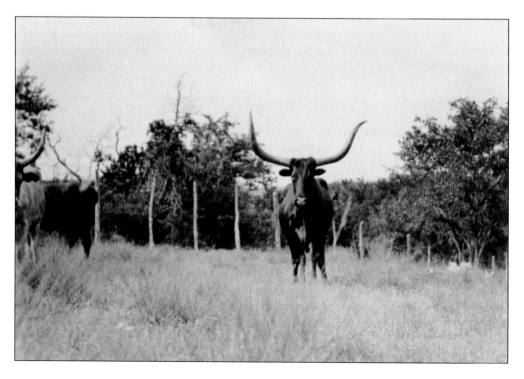

Wyoming became an incorporated territory of the United States in 1868; prior to that, it had been part of the Dakota Territory. The 1870 census counted 9,118 residents, the majority of them living in Cheyenne, Laramie (pictured below), and a few other towns strung along the east-west Union Pacific Railroad corridor. At this time, the 97,814 square miles that comprised the Wyoming Territory were unfenced and mostly unclaimed by homesteaders, who were entitled to 160 acres each under the 1862 Homestead Act. The scarcity of population left the region wide open for the development of the livestock industry and drew all kinds of men eager to make their fortune on the vast grassy plains of southeastern Wyoming. (Both, ARC.)

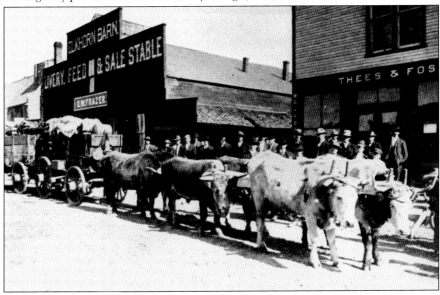

13

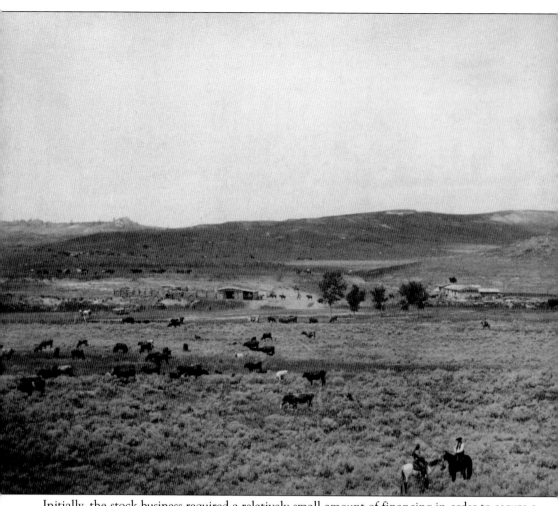

Initially, the stock business required a relatively small amount of financing in order to secure a herd and hire help. A purchase of land was not considered essential, as most of it still remained in the public domain. In essence, the native grasses, which had nourished the vanishing buffalo herds for so long, provided free feed for a rancher's cattle, no matter how many or how far-ranging they were. (ARC.)

The early outfits established their headquarters, like the one seen here, near the meandering rivers and streams on a first come, first served basis. By doing so, they believed it also guaranteed them primary control of the water rights, very important in the arid west, over the latecomers and homesteaders who inevitably followed. Water rights disputes among landowners, the state, and other entities are still quite common today. (AHC.)

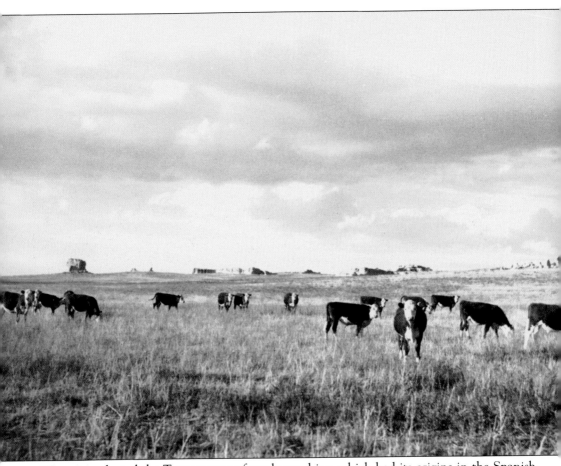

Wyoming adopted the Texas system of cattle ranching, which had its origins in the Spanish methods that were introduced to the New World in the 1500s. This system depended upon the vast unfenced grasslands of the public domain, where cattle were turned loose to forage and wander hundreds of miles of open range. No one watched over them or provided food when snow and ice covered the high-altitude plains for long periods of time. For the most part, human interaction with the animals occurred twice a year: for branding in the spring and shipping in the fall. (ARC.)

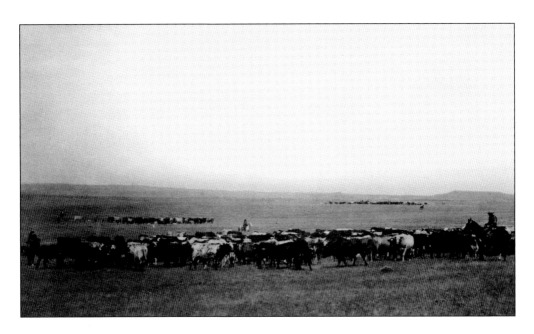

Naturally, over time, cattle intermingled on the open range. The spring roundup separated the herds of each ranch (as shown above) and marked the calves with the owner's individual brand. For huge herds, the spring roundup could take two to three months, and one documented case involved 400 men (who might have represented 20 different outfits), 1,400 horses, and 27 wagons. Under the supervision of a foreman, cowboys rode miles each day in search of calves and cows and brought them to a central location for branding (below in this 1880s photograph). The entire crew, horses, and wagons moved many miles in search of the wandering cows and established temporary camps numerous times during the course of a roundup. (Above, AHC; below, ARC.)

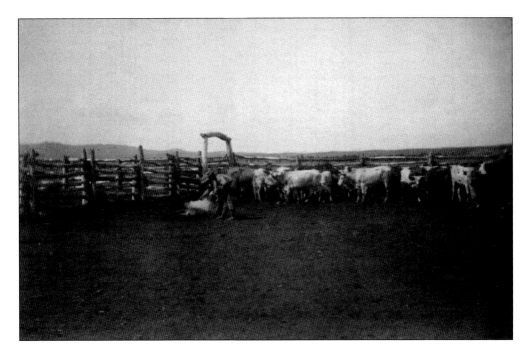

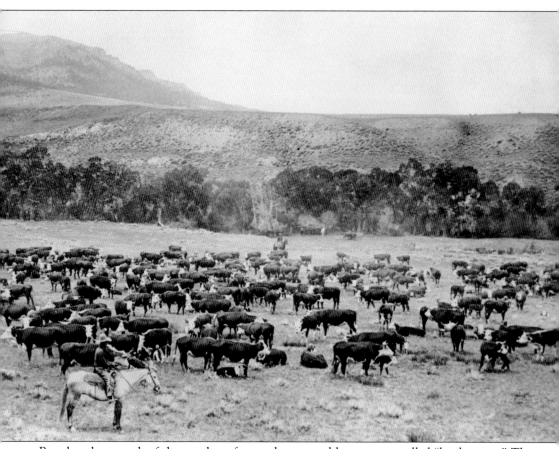

Ranchers kept track of the number of cows they owned by a system called "book count." The book count often underestimated the actual numbers on the far-flung range, which worked to an owner's advantage for taxes. Likewise, an overestimated book count would be advantageous for a ranch sale to a distant investor or absentee owner. In fact, the uncertainty of a count conducted only once or twice a year is understandable given the vagaries of large herds, distant grazing practices, animal survival rates, and unpredictable weather. It became an accepted part of the ranching system during the open range era. (ARC.)

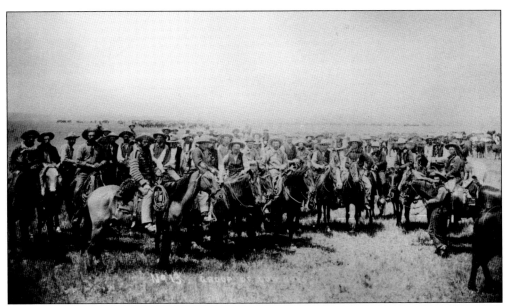

Often romanticized, the life of a cowboy was anything but. Hired for long hours in the saddle during the two yearly roundup seasons, only a few top hands found full-time employment. Many cowboys faced winters on their own, with no work, no money, and no home. They often survived the bleakest season by "riding the grub line," a practice whereby a ranch provided them a place to stay but no wages. One source noted that monthly wages (with room and board) remained about the same during the 30-year period following the Civil War, with the typical cowboy earning around $30, a top hand receiving $40–$45, trail bosses paid $50–$60, and range foremen collecting the highest wage, about $125. As ranching developed following the open range period, the need for labor decreased due to fencing and the streamlining of operations. (Both, AHC.)

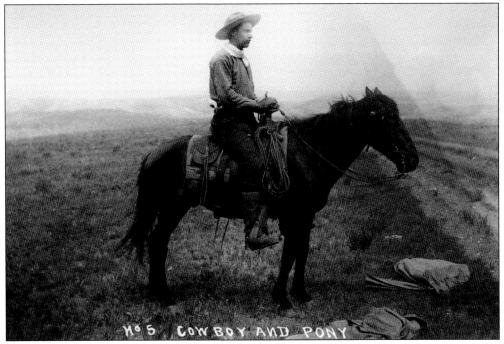

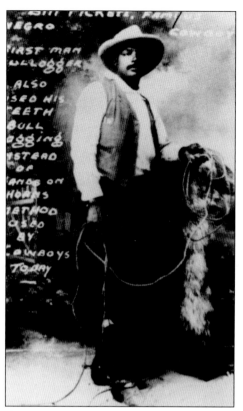

Although the cowboy image is usually of a young white male, the reality is that an estimated one-third of them were black, Mexican, or Indian. Texan Bill Pickett (left), the son of a slave, became a cowboy and, later, a famous rodeo star. A number of black cowboys came up the Texas Trail to Wyoming on the early cattle drives. Some remained in the state and became ranchers. When cowboys came to Cheyenne, they often had professional photographs taken of them in their best clothes. The group below includes a black cowboy on the town in Cheyenne. (Both, ARC.)

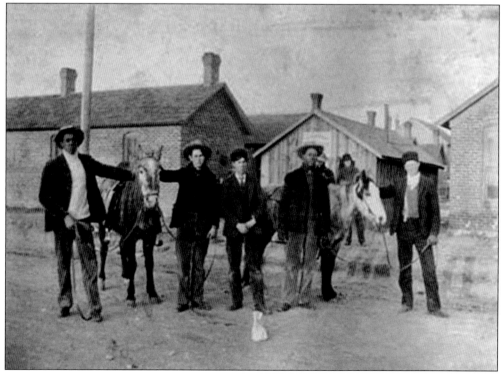

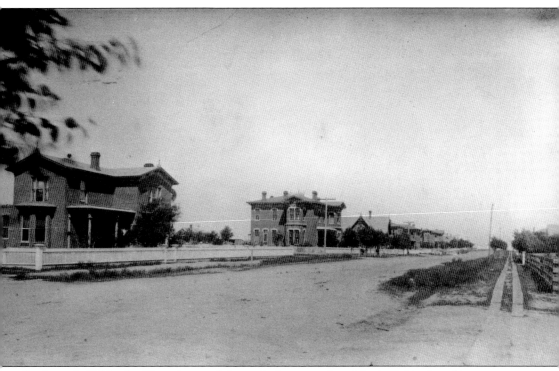

By the early 1880s, the Wyoming cattle boom had attracted wealthy individuals and investment companies not only from the East Coast but also from Scotland and Britain. Young men, scions of East Coast or British Isles aristocracy, visited Wyoming Territory and welcomed the new opportunities offered there for adventure and wealth. National and international companies sent their representatives to Wyoming in order to assess the potential of a large investment in the cattle industry, which included either the establishment of a cowherd and a ranch or the purchase of existing ones. So much money poured into the small city of Cheyenne, home to many of the cattle barons, that various sources claimed it was the wealthiest city per capita in the world. The image is of Cheyenne's "Millionaires' Row," where many cattle barons built lavish mansions in the 1870s and early 1880s. (ARC.)

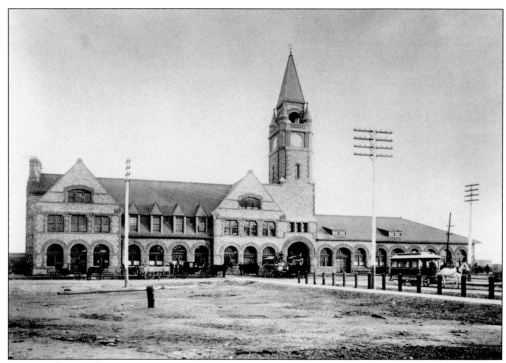

The power of the railroads and the prominent role they played in the development of the western range cattle business cannot be underestimated. The Union Pacific's (UP) 1867 designation of Cheyenne as a major division point on its rail line helped the small city become the central shipping point of the northern range for a number of years. In the midst of the cattle boom year of 1885, the UP agreed to build an impressive depot for the city, reflecting the prominence of both the railroad and the wealthy city. The Cheyenne Stockyards (below) became a busy place during shipping season. (Both, ARC.)

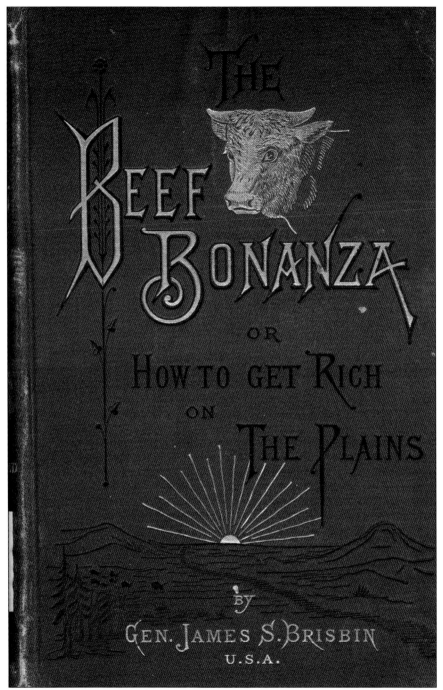

The Beef Bonanza; or, How to Get Rich on the Plains. By Gen. James S. Brisbin, U.S.A.

Far from the hub and frenzy of cattle activity, newspapers and other publications helped generate interest and excitement among their readers. Cattle dealer Joseph G. McCoy wrote a book about the industry titled *Historic Sketches of the Cattle Trade of the West and Southwest* in 1874. Another popular book appeared in 1881, *The Beef Bonanza; or, How to Get Rich on the Plains,* penned by James S. Brisbin, a career Army officer who had spent years on the western plains. His book promised a large profit from an investment in range cattle. (Brisbin.)

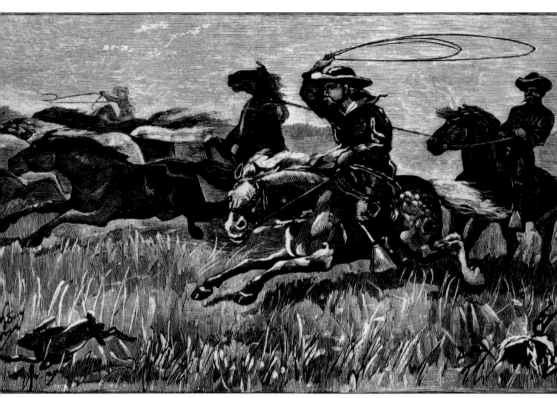

The open range system, which captured the imaginations of visual artists, writers, and filmmakers for decades, basically came to an end in 1886–1887. The reality is that it existed for only a short period of time, from the late 1860s through the mid-1880s, during which time the northern plains presented a unique opportunity for wealth, for a few, due to the millions of acres of unfenced "free" grasslands and the lack of permanent settlement. Much changed after the brutal winter of 1886–1887. (Brisbin.)

Two

THE CATTLE BARONS

Certainly not all the cattle barons had tony pedigrees, but men like Hiram "Hi" Kelly got in early enough to make a fortune. Kelly had knocked around the west for years, beginning in 1849, when, at the age of 15, he drove an ox team from Independence, Missouri, to California. Kelly picked up jobs as a woodcutter, stagecoach driver, and storekeeper before arriving in Cheyenne in 1870. He bought a few hundred cows and established a ranch 50 miles north of Cheyenne, the Two-Bar, seen here. (ARC.)

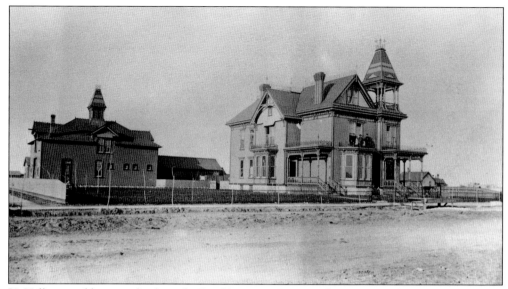

Hi Kelly reaped large profits from the Beef Bonanza. In 1884, the Swan Land & Cattle Company bought his Two-Bar Ranch for $250,000, and Kelly returned to Cheyenne and constructed a large mansion at Twenty-fourth Street and Ferguson (later Carey) Avenue. In the 1880s, Ferguson Avenue, known as "Millionaires' Row," became home to many of the cattle kings, who lived an opulent lifestyle in town. Kelly died bankrupt in Denver in 1924. (ARC.)

Thomas Sturgis became one of Wyoming's most prominent cattle barons. Born to a wealthy New York City family in 1846, Sturgis served in the Civil War and then headed west in 1867. Following a farming stint in Missouri, he established a Wyoming ranch in 1873. As did other well-connected stockmen, Sturgis also developed business interests in mining and railroads. Sturgis played a crucial role in the organization of the cattle industry as the secretary of the Wyoming Stock Growers Association for 11 years. (AHC.)

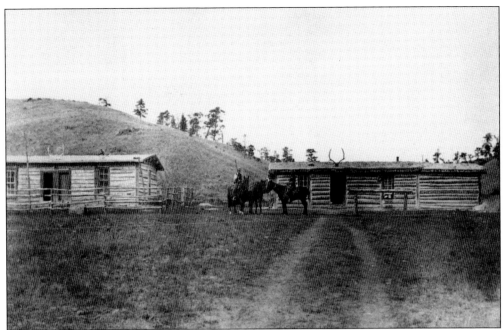

Sturgis ranched with a number of partners, including Gorham G. Goodell, with whom he set up his first operation, known as Sturgis & Goodell, located on Horse Creek. Sturgis also formed partnerships with his brother William, who lived in Cheyenne, his father, and a good friend from New York City, William C. Lane. The headquarters for the Sturgis & Goodell Ranch in 1884 consisted of two log buildings (above). Like most cattle kings, Sturgis also had a large house in Cheyenne (below), where he resided most of the time. (Both, AHC.)

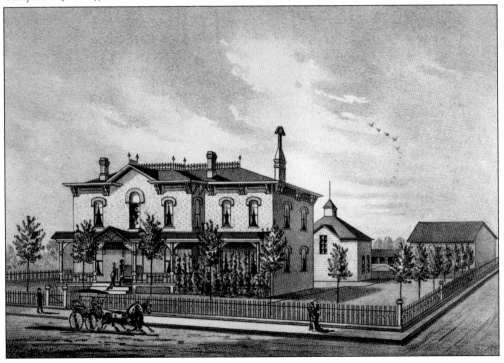

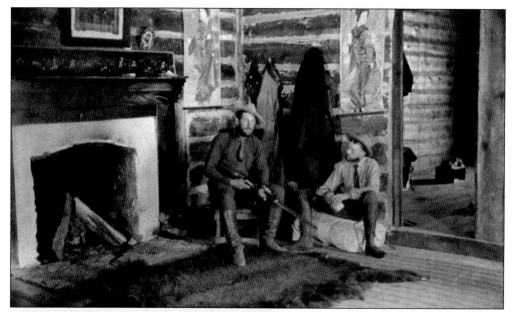

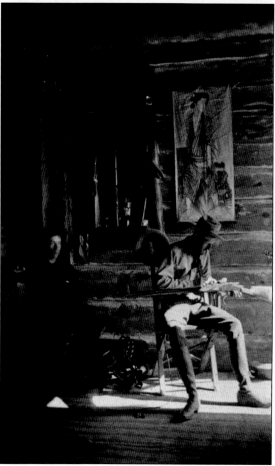

Photographs of the interiors of early ranch buildings are rare. The two seen here, from around 1885, show one of the Sturgis & Goodell headquarters buildings, which was quite well appointed for the time and surely was not the bunkhouse. The large Oriental hangings could be items Sturgis brought from home, acquired from his father's prestigious import trade business. Prints and a photograph or two also ornament the walls. Note the thickness of the logs walls. The men in the photographs are not identified, but Sturgis is not one of them. Sturgis left Wyoming for New York City after the disastrous 1886–1887 winter, serving as the fire commissioner there for two years. He died of cancer while residing in England in 1914. (Both, AHC.)

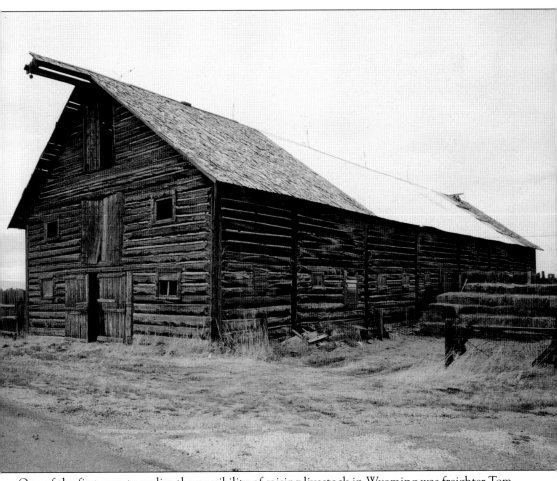

One of the first men to realize the possibility of raising livestock in Wyoming was freighter Tom Alsop, who, along with two partners, established a cattle and sheep ranch eight miles northwest of Laramie on the Laramie Plains. By 1870, the *Laramie Boomerang* newspaper reported that they shipped by rail 3,000 head of "choice mountain-fed cattle" to eastern markets. The horse barn seen here is one Alsop had built on another ranch he owned. It still stands today. (RC.)

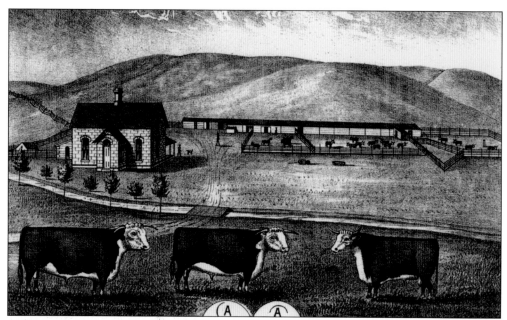

Andrew Gilchrist, a native of Scotland, immigrated to the United States in 1865. He drove a large herd of cattle to the grasslands west of Cheyenne in 1873, where he and his family established the Crow Creek Ranch. The son of a prominent cattle breeder, Gilchrist was interested in the improvement of cattle breeding, and he introduced purebred Herefords into his herd. A prominent member of the Wyoming Stock Growers Association during the 1880s cattle boom, Gilchrist also served in the territorial legislature. His well-built sandstone house (below), constructed in 1879, still stands today. (Above, ARC; below, RC.)

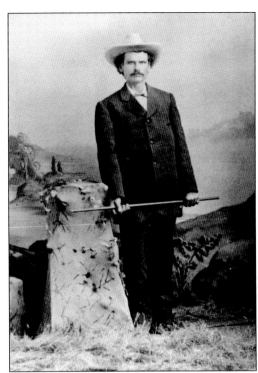

Not all cattle barons operated in the Cheyenne orbit, maintaining a mansion there and participating in the local high society. Tom Sun (right), although he operated on a smaller scale than most of the other cattle kings, became one of Wyoming's best-known and most-respected cattlemen. Born to a French-Canadian family in Vermont in 1844, Thomas DeBeau Soleil (the French word for "Sun") left home at a young age and made his way to Wyoming. He began ranching in 1872 along Wyoming's Sweetwater River (below) near Devil's Gate and Independence Rock, two famous Oregon Trail landmarks. (Right, AHC; below, RC.)

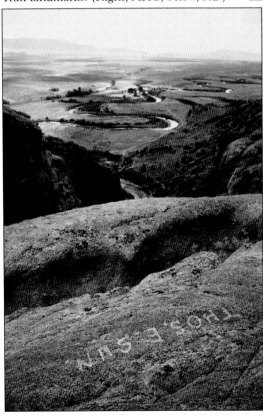

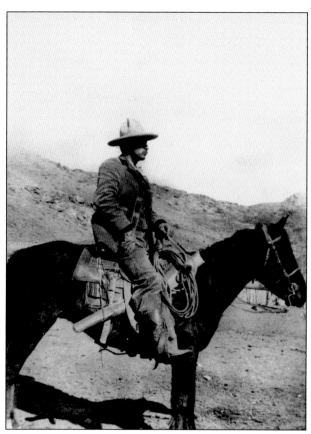

The story of John Kendrick, Wyoming's quintessential cowboy and cattle baron, is truly legendary. Born a Texan in 1857, orphaned at a young age, and raised by a half sister and her husband, Kendrick first came to Wyoming as a cowboy on an 1879 cattle drive. Not the average hired hand, he purchased his first few cows with wages from the drive, eventually building a herd. One of the few cattlemen not devastated by the 1886–1887 winter, he became superintendent of the large Converse Cattle Company, headquartered at the OW Ranch, near Lusk. In 1889, he relocated the entire operation north to better rangelands that straddled the Wyoming-Montana border. Kendrick eventually purchased the outfit in 1897. The photograph of John Kendrick at left was taken in 1895. Cowboys are pictured below in front of the Wyoming OW bunkhouse. (Left, TE; below, AHC.)

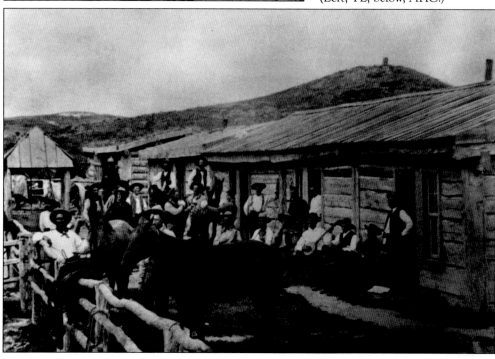

Over the years, Kendrick built a ranching empire of over 210,000 deeded and leased acres in northern Wyoming and over the border into Montana, where he located the ranch headquarters of the OW Ranch. He and his young family lived at the OW for a number of years but also spent time in nearby Sheridan, Wyoming. In 1910, Kendrick hired Oscar Husman, a Swedish-born stonemason, to build a showcase ranch, the LX Bar, located on the banks of Wyoming's Powder River in northwestern Campbell County. The sandstone buildings included a large five-bedroom house (to the left in the photograph above), two massive barns, a bunkhouse, a laundry-kitchen, and a chicken house (below). Although Kendrick never lived at the LX Bar, he employed his nephew Tom Kendrick as ranch foreman for 34 years. It took one day for Kendrick to reach the LX Bar from the OW Ranch in Montana. (Both, RC.)

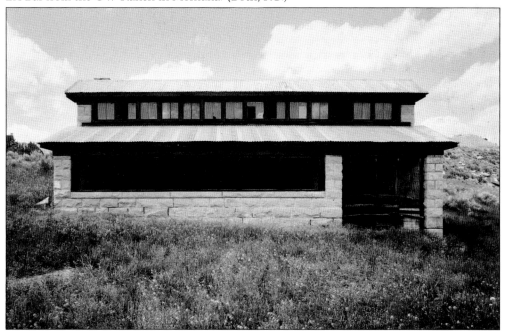

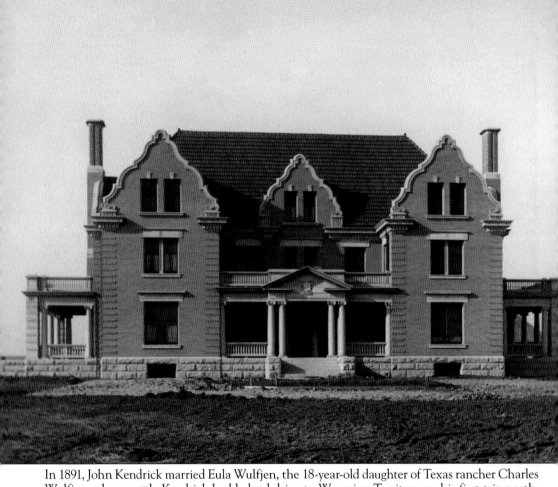

In 1891, John Kendrick married Eula Wulfjen, the 18-year-old daughter of Texas rancher Charles Wulfjen, whose cattle Kendrick had helped drive to Wyoming Territory on his first trip north. The couple and their two children lived at the OW Ranch until 1908, when they moved to Sheridan and lived in the carriage house while their 30-room mansion, Trail End, seen here in 1911, was constructed on a prominent hill that overlooked the town. Although ranching remained Kendrick's primary interest, he also invested in banking and real estate in Sheridan. After his death in 1933, Eula lived at Trail End until 1960. In 1968, the Sheridan County Historical Society saved the house from demolition, and it is now a public museum owned and operated by the State of Wyoming. (TE.)

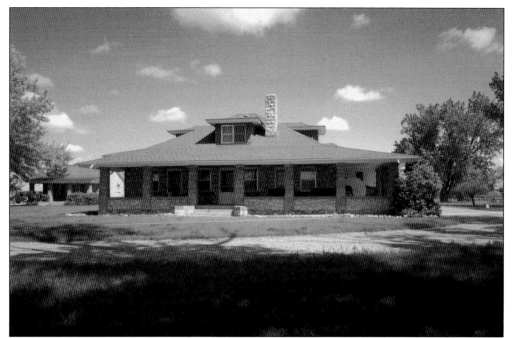

In 1924, Kendrick contracted again with Husman to construct another large stone ranch complex known as the K Ranch (main ranch house above, laundry "room" below). The K provided winter range for Kendrick's cattle, and he developed an extensive irrigation system there for the purpose of growing hay for winter feed. By this time, he lived far away from his ranches, in Washington, DC, where he served as a US senator representing Wyoming from 1917 until his death in 1933. (Both, RC.)

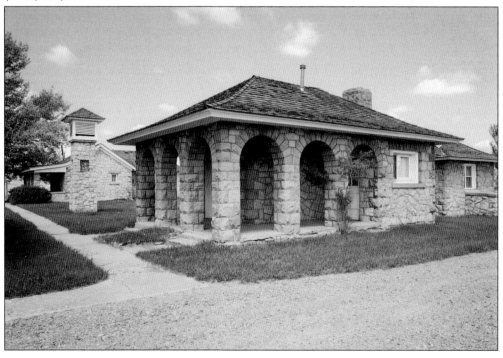

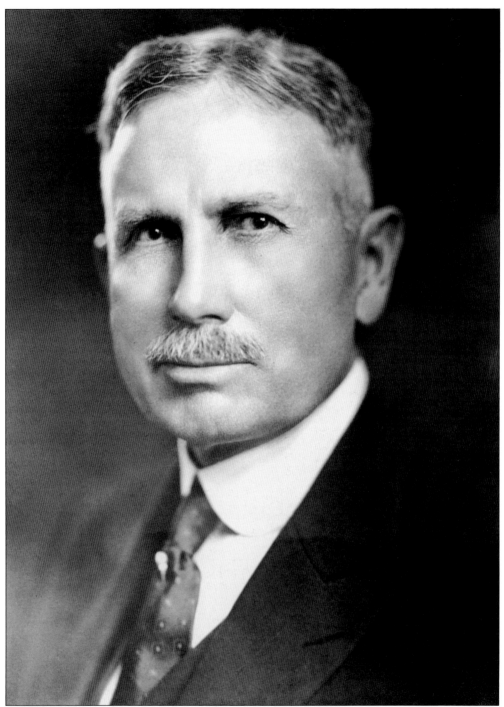

Kendrick, a Democrat, won the senatorial race in 1916 after only two years as the state's governor, during which time he lived in Cheyenne. Always a proponent of large water projects in the arid west, he became a powerful voice for agriculture. Once a cowman, always a cowman, Kendrick kept close tabs from afar on his western empire and wrote in 1924, "Those who have grown up with the business can never escape the call of the range." (ARC.)

Three

BRITISH AND SCOTTISH INVESTMENT IN THE CATTLE BOOM

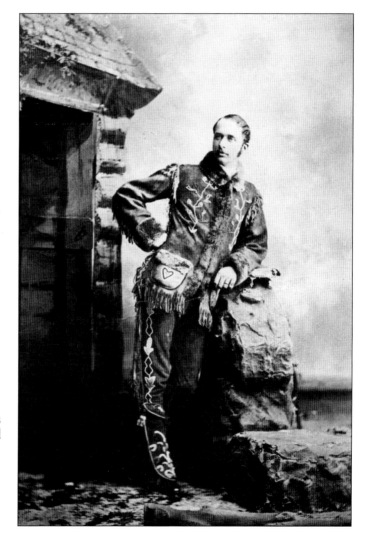

Moreton Frewen, a wealthy Englishman, first saw Powder River country on a big game hunting trip in 1878. That area in northern Wyoming Territory had recently opened for settlement following the 1874 Black Hills gold rush, when the US government revoked an 1868 Indian treaty that had guaranteed that the tribes kept the hills, their sacred land. Frewen and his brother Richard established a large cattle ranch, the 76, on the banks of Powder River, near present-day Kaycee. Moreton Frewen is pictured here dressed in western garb. (AHC.)

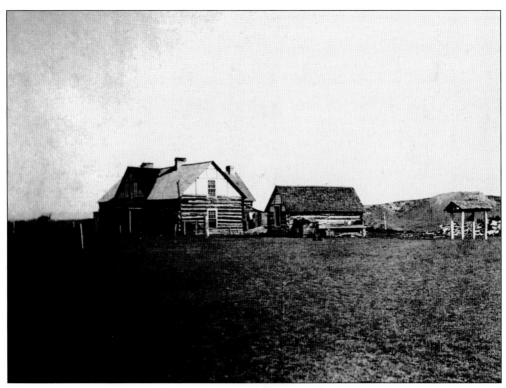

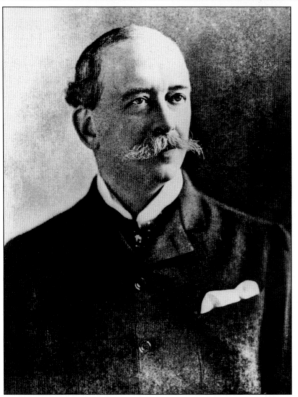

The young, imperious Frewen brothers lived in what was known as "Frewen's Castle," a large two-story log house (above). They entertained "practically all the high-ranking nobility of the time . . . with gay parties and balls, and thrilling big game hunts," as noted by John Burroughs. Family members and English friends purchased shares in the cattle outfit, which helped finance the Frewens' lavish lifestyle. They reportedly employed 75 cowboys, who ran the herd of over 60,000 cows. The brothers liquidated their cattle holdings in 1886 and returned to England. Frewen's Castle is now long gone. Moreton Frewen is seen at left in the 1880s. (Above, AHC; left, ARC.)

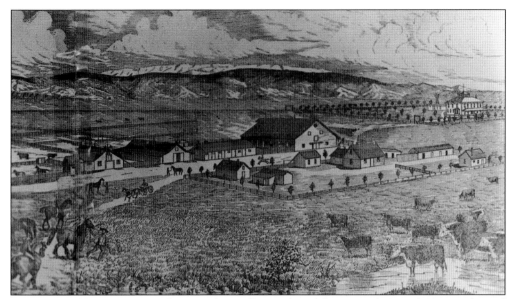

In 1883, wealthy Scotsman John Douglas-Willan and British aristocrat Lionel Sartoris formed the DWS partnership to raise cattle on the Laramie Plains. Like other members of their class, the two young men, described as "waxed mustached British dandies" by one associate, built a large, 20-room house on the plains where they lived in luxury. They hosted many parties and balls for their wealthy friends where liveried servants waited on them. (AHC.)

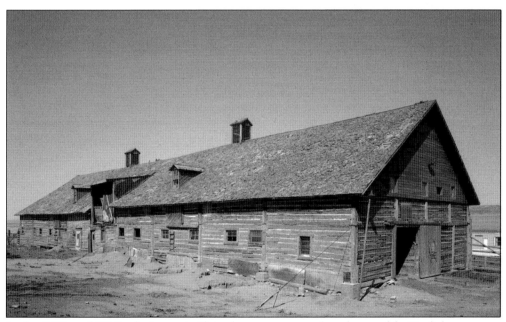

In the 1880s and 1890s, the Laramie Plains became a center for other wealthy Englishmen eager to get in on the cattle bonanza. Two of them, Dr. A.W. Whitehouse and a Mr. Stokes, established the Oxford Horse Ranch. The men at one time owned 3,000 Thoroughbred horses, and they often hosted races for their British friends on their nearby half-mile race track. The massive Oxford Horse barn, seen here, stills stands today. (RC.)

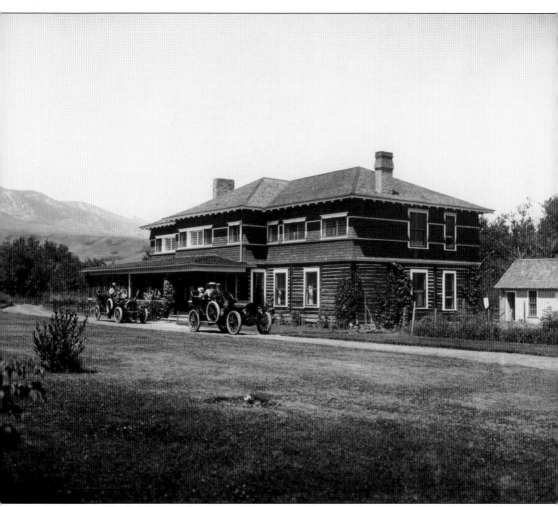

Farther north, the area around Sheridan also became known for its English gentry. Oliver Henry Wallop, who later became the eighth Earl of Portsmouth, was born in 1861 and came west in 1883, first to Montana and then south to Wyoming, where he established the Canyon Ranch. Wallop, along with other young wealthy Englishmen who set up ranches in the west, were known as "remittance men," younger sons of British families who, due to inheritance laws, would not inherit the family seat or a title. Their family fortunes helped support their ranching operations. (ARC.)

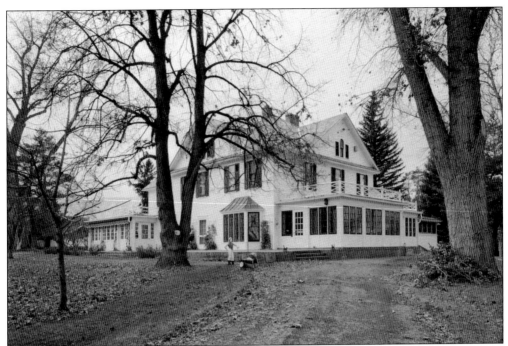

Brothers Malcolm and William Moncreiffe, sons of a Scottish lord and cousins of Oliver Wallop, also settled in the Sheridan area in the 1890s at their ranch, the Quarter Circle A. In addition to cattle and the cavalry and draft horses they sold to Great Britain for use in the South African Boer War, the brothers raised and trained polo ponies. They brought the sport of polo to northern Wyoming and formed a polo team. The 1920 photograph below features four polo players. The ranch is now known as the Brinton Museum (above), named after Bradford Brinton, who purchased the ranch in 1923. (Above, RC; below, ARC.)

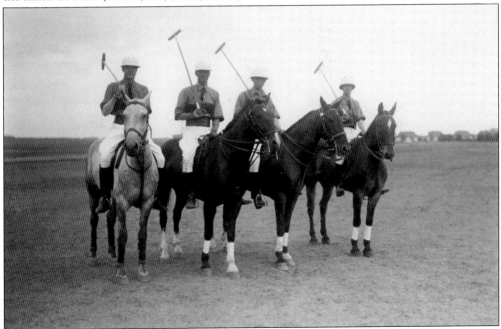

The Swan Land & Cattle Company, seen above in 1903 and located in Chugwater, became Wyoming's largest ranch by 1885 and remains one of the most famous ranches in the west. In its heyday, around 1885, the Swan, according to some accounts, controlled 200,000 head of cattle, and its roundup area ranged over one million acres of land stretching from Ogallala, Nebraska, to Fort Steele, Wyoming. The company was organized in 1883 and backed by Scottish investors. The photograph below shows the interior of the Swan ranch house. (Above, RC; below, ARC.)

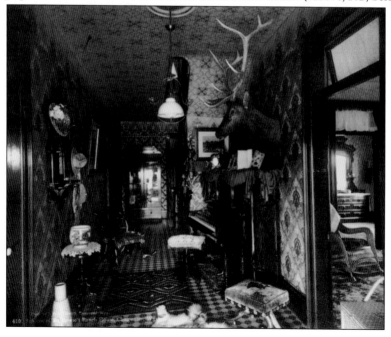

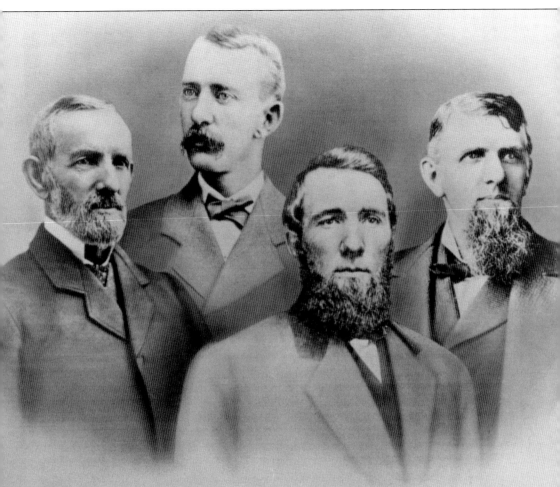

HENRY SWAN WILLIAM F. SWAN THOMAS "BLACK TOM" SWAN ALEXANDER H. SWAN

SWAN BROTHERS

Alexander Swan, a Pennsylvania native, arrived in Cheyenne in 1873. At age 42, Swan was older and more experienced than many cattlemen of the time, having dealt livestock in Iowa. He formed a partnership with two brothers and a nephew called the Swan Brothers Cattle Company. In 1883, Swan, along with Scottish backers who became the board of directors, reorganized the outfit under a new name, the Swan Land & Cattle Company, with Swan as ranch manager. (ARC.)

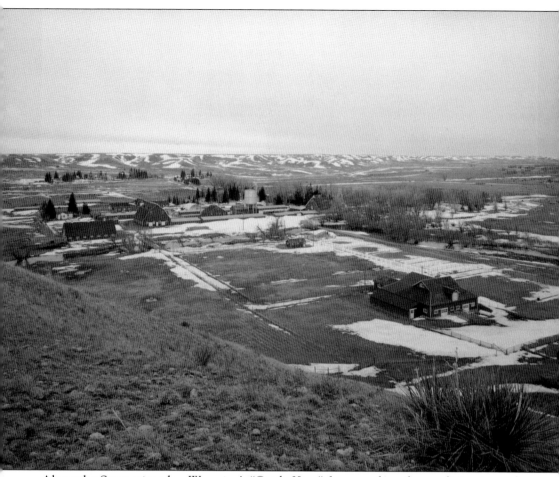

Alexander Swan reigned as Wyoming's "Cattle King" for a number of years, living in opulent style. He also established the famed Wyoming Hereford Ranch, located just east of Cheyenne, during this period. (RC.)

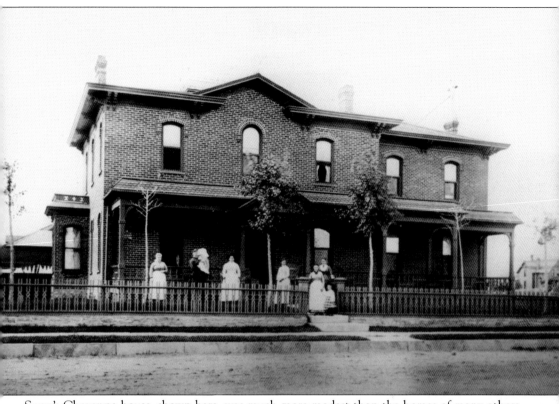

Swan's Cheyenne house, shown here, was much more modest than the homes of many others in his position. His great empire collapsed in 1887, and he resigned as manager of Swan Land & Cattle, accused by one contemporary critic of giving the "Western cattle business a very black eye . . . of pyramiding one debt upon another, . . . skillfully concealing the weak points and boosting the strong ones" to the distant, unsuspecting Scottish board, as recorded in *My Life on the Range*. The practice of using an inflated "book count" contributed to Swan's downfall. (ARC.)

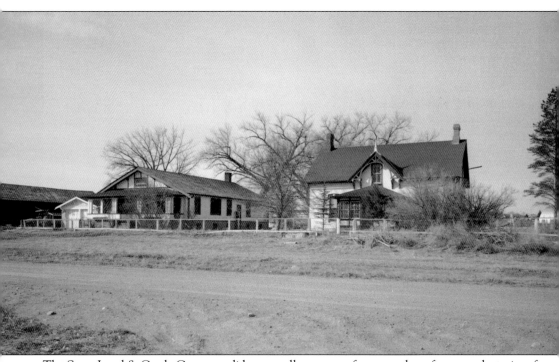

The Swan Land & Cattle Company did eventually recover after a number of years and a series of managers. In 1910, the company turned the operation into a sheep outfit and changed its name to the Swan Company. It sold its Wyoming holdings in the 1940s. Four of the old buildings, including a bunkhouse built in the 1900s, still stand today but have been neglected and vandalized for years. Alexander Swan left Cheyenne in the 1880s and died in Ogden, Utah, in 1905. This photograph shows the bunkhouse (left) and the house (right). (RC.)

Four

THE MIGHTY WYOMING STOCK GROWERS ASSOCIATION

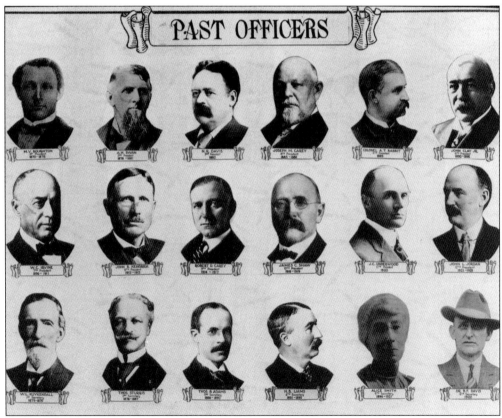

In 1873, five Wyoming cattlemen met in Cheyenne and formed an organization called the Stock Association of Laramie County, which later became the Wyoming Stock Growers Association (WSGA). They resolved "to present a Bill for better protection of Stock and Stock interests." Pictured are some of the early association officers. (AHC.)

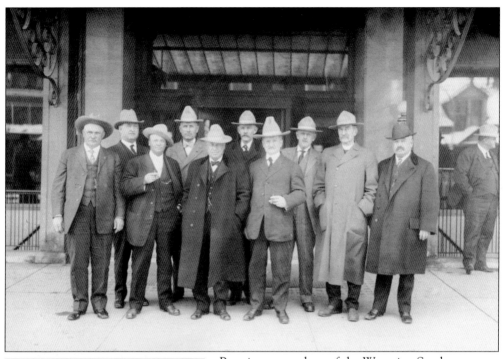

Prominent members of the Wyoming Stock Growers Association are seen here at the 1914 convention in Cheyenne. Many of them participated in the largest roundup in Wyoming Territory in 1884, when they were all young cowboys. John Kendrick is fourth from the left. (ARC.)

By legislation, the Wyoming Stock Growers Association (WSGA) gained control of the twice-yearly roundups whereby a rancher assessed his inventory. Branding was crucial during the roundups, as it established the ownership of calves that had been born on the open range and grazed far from the home ranches. The WSGA published an annual brand book that identified registered brands of individual ranches. Many ranches had more than one brand. This photograph shows a page from an 1884 brand book. (AHC.)

The WSGA quickly became a powerful lobbying organization for the large cattle operators and played a key role in creating laws governing the stock industry. Membership numbered over 400 by 1885, and some served in the territorial legislature or influenced legislation in other ways. Scotsman John Clay, seen here, a prominent member who managed the Swan Land & Cattle Company, noted that "its members were generally an exceedingly bright set of men . . . young, courageous, possibly wanting in conservatism." (AHC.)

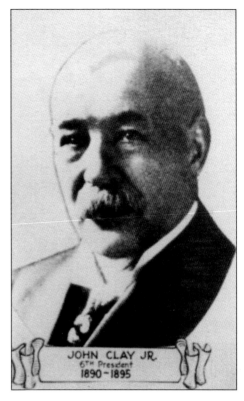

Unbranded cows and calves that may have been owned by someone other than a WSGA member but that were not gathered in the roundup became known as mavericks and were easy targets for cattle rustling, which increased as the number of range cattle multiplied dramatically. In 1884, legislation on behalf of the WSGA furthered its control over the roundups by forbidding anyone other than the association to brand the mavericks. The WSGA then sold them to the highest bidder, pocketing the proceeds and adding to its rich coffers. This undated drawing may be from the 1870s. (AHC.)

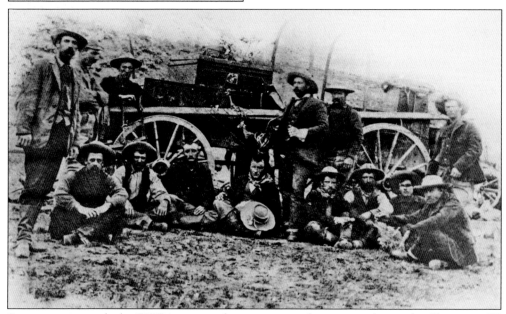

Cattle rustling had always been a concern of the association, and it hired stock detectives to ferret out rustlers. However, the hundreds of miles that cattle grazed could not be patrolled, and dishonest men altered brands on marked cows and then claimed them. The WSGA often suspected cowboys, some of whom ran the few cows they owned with their employer's herd, of rustling and then blackballed them. Letters from ranch foremen like this one could vouch for a cowhand and request his removal from the black list. (AHC.)

Resentment towards the WSGA grew as the organization became, in the words of historian W. Turrentine Jackson, "the de facto territorial government." The elite association denied membership to many small-time ranchers, some of whom it believed were rustlers. To further exacerbate the situation, an increasing number of "nesters" claimed 160-acre homesteads on thousands of acres that had not been owned but had been tacitly controlled by individual members of the WSGA for years. This 1884 photograph of the Bar C roundup wagon includes men the association considered outlaws. (AHC.)

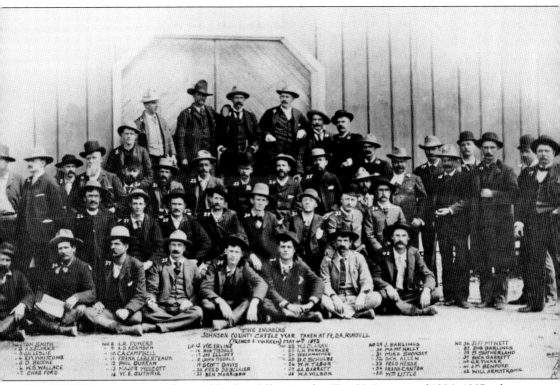

"THE INVADERS"
JOHNSON COUNTY CATTLE WAR TAKEN AT Ft. D.A. RUSSELL
(FRANCIS E. WARREN) MAY 4th 1892

NO. 1 TOM SMITH
2 A.B. CLARKE
3 J.N. LESLIE
6 EM WHITCOMB
5 D. BROOKE
6 W.B. WALLACE
7 CHAS FORD

NO. 8 A.R. POWERS
9 A.D. ADAMSON
10 C.A. CAMPBELL
11 FRANK LABERTEAUX
12 PHIL DUFRAN
13 MAJOR WOLCOTT
14 W.E. GUTHRIE

10.12 WC IRVINE
16 BOB TISDALE
17 JOE ELLIOTT
18 JOHN TISDALE
19 SCOTT DAVIS
20 FRED DE BILLIER
21 BEN MORRISON

NO. 22 W.J. CLARKE
23 L.H. PARKER
24 TESCHMACHER
25 B.C. SCHULZE
26 W.H. TABOR
27 J.J. GARRETT
28 W.A. WILSON

NO. 29 J. BARLINGS
30 M.A. MC NALLY
31 MIKE SHONSEY
32 DICK ALLEN
33 FRED HESSE
34 FRANK CANTON
35 WM LITTLE

NO. 36 JEFF MYNETT
37 BOB BARLINGS
38 S. SUTHERLAND
39 RICK GARRETT
40 G.R. TUCKER
41 J.M. BENFORD
42 WILL ARMSTRONG

The WSGA lost its most influential leaders following the "Die-Up" winter of 1886–1887, when fierce blizzards and temperatures well below freezing persisted, causing the deaths of hundreds of thousands of cows that froze or starved on the heavily overstocked range. Many members lost their fortunes and simply left town for good. This collapse of the open range system was one cause that led to the notorious Johnson County War of 1892, in which participating WSGA members became known as "the Invaders." This photograph shows WSGA members and their hired guns from Texas. (AHC.)

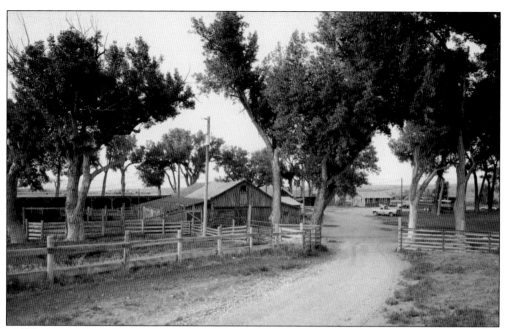

In spite of attempts by some association members to prevent it, in April 1892, a group of 24 or 25 representatives of the WSGA, accompanied by an equal number of hired Texas gunmen, traveled north to Johnson County, where cattle rustling had become rampant. They intended to enforce the rustling penalties that they believed the local law had ignored, thereby defying the WSGA. After killing two suspected rustlers along the way, the group unexpectedly met up with 300 heavily armed independent ranchers, nesters, and others who had been tipped off to the impending "Invasion." The Johnson County men surrounded the TA Ranch (above), where the outnumbered WSGA members had taken refuge in a barn. The map of the TA below is likely from the same time period as the Invasion. (Above, RC; below, AHC.)

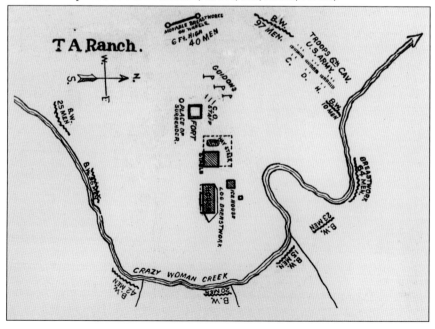

The Invaders cut portholes in the barn walls, which can be seen outside the hayloft in this photograph, where they positioned their weapons to defend themselves against the siege, which lasted three days. They managed to get word of their plight to Gov. Francis Warren, himself a prominent WSGA member, in Cheyenne, who called upon Pres. Benjamin Harrison to send federal troops from nearby Fort McKinney to rescue the Invaders, who then surrendered, thereby ending the Johnson County War. (RC.)

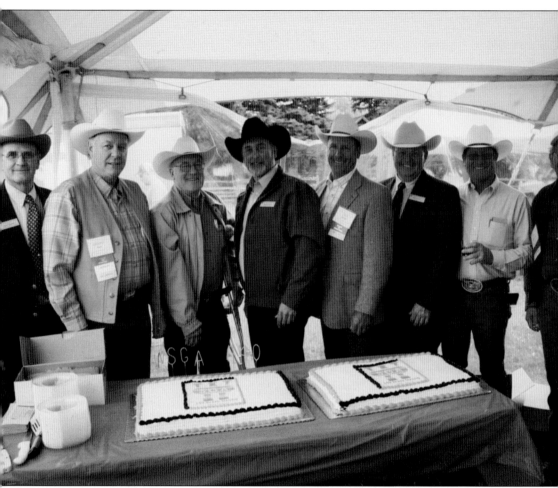

The Invaders returned to Cheyenne, faced murder charges, and remained imprisoned until their release in January 1893. It has never been agreed upon which side was "right" in the famous cattle war, but many have interpreted it as the final chapter of Wyoming's open range cattle industry. And never again did the WSGA have the political and financial power it had once exerted. It did, however, survive, and the well-respected organization has over 1,200 members today. This photograph shows WSGA officers. From left to right are Joel Ohman, Dennis Sun, Jim Wilson, Mark Eisele, Jack Berger, Rob Crofts, Dennis Thaler, and Jim Magagna. (WSGA.)

Five

THE CHEYENNE CLUB

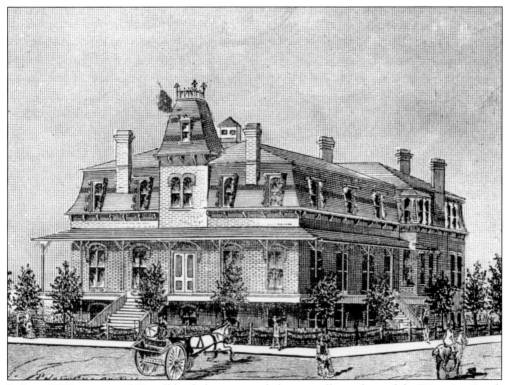

In June 1880, a group of 12 well-heeled young cattle barons, all members of the Wyoming Stock Growers Association, met and established a social club, which they first named the Cactus Club but later renamed the Cheyenne Club. As founding member Thomas Sturgis wrote, "We expect to furnish the members a substitute for and an improvement on the old Railroad House . . . in short a good club on an eastern basis. . . . We feel it will fill a social want that we have long felt." This drawing shows the Cheyenne Club in the early 1880s. (ARC.)

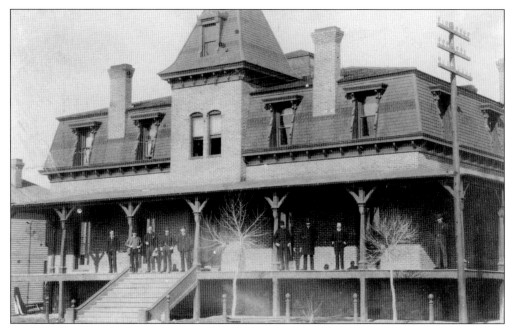

In 1880, Cheyenne had a population of just 3,500 people and lacked the finer amenities many of the Cheyenne Club founders had known at their homes back east, where a number of them had attended Ivy League colleges. "The Club," as it became known, quickly incorporated, established bylaws, and sent formal invitations to 46 prominent potential members. It purchased a lot in downtown Cheyenne and had a new three-story brick clubhouse built that opened in 1881. The new clubhouse is pictured here. (ARC.)

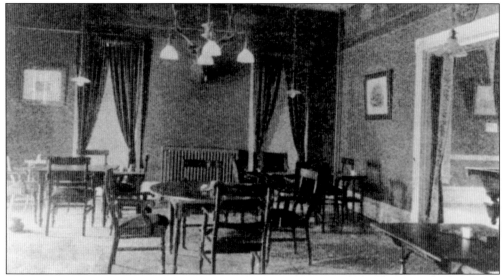

The well-appointed clubhouse cost $25,000 to build and featured a kitchen and wine vaults on the lower level and a hardwood-paneled dining room (seen here), a smoking room, a billiard room, and a reading room on the first floor. Agnes Wright Spring wrote, "Carpets covered the stairs, café and reading room. . . . Six sleeping rooms upstairs were furnished with the best quality of carpets and ceiling-high, walnut wardrobes, dressers, and commodes with marble tops, and handcarved walnut beds. There was a well-equipped bath." (ARC.)

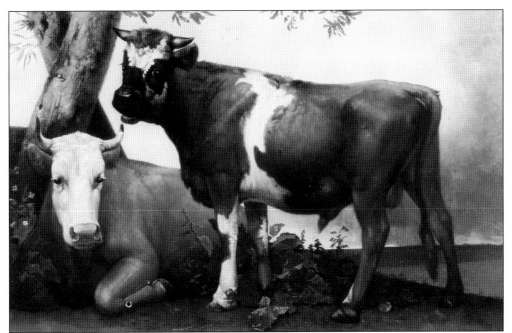

A reproduction of a detail from a 1674 painting by Dutch artist Paulus Potter hung on a club wall. In the 1890s, member John Coble became drunk, which was against the Club's rules, and fired shots from his .45 at the bull while proclaiming, "Wyoming ain't going to have anything like that on our ranges, are we boys?" The Club revoked Coble's membership. The painting, with a bullet hole visible on the leg of the cow on the left, is seen here. (WSM.)

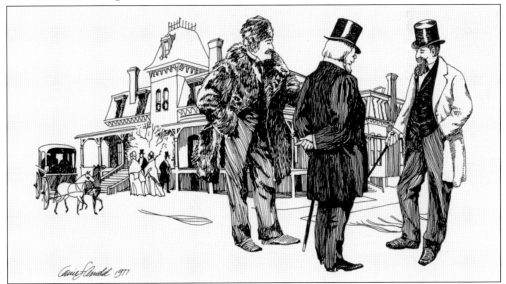

The Cheyenne Club became a legend in its own time. It served the finest food and liquor, which arrived on the train from New York and San Francisco. Inferior cigars led one member to write to the dealer, "The . . . cigars are too dark. . . . Please take special pains to send the lightest possible." The Club entertained female guests at certain functions like Christmas and military balls. The cattlemen conducted business there, and the most influential men in the city became members. This drawing shows the Club on Christmas Day. (AHC.)

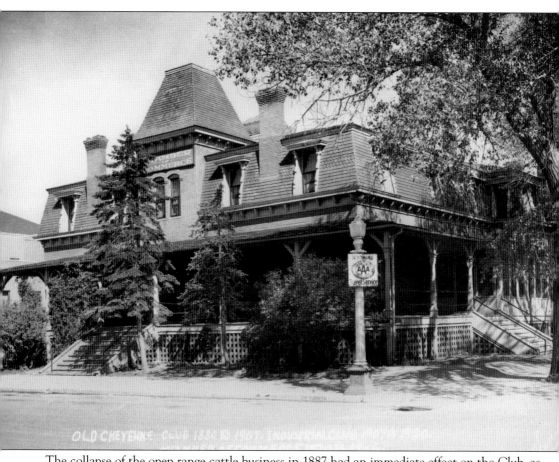

The collapse of the open range cattle business in 1887 had an immediate effect on the Club, as many wealthy members lost their fortunes and quickly returned to their native cities and their family money. Times changed, and the lavish lifestyle of the cattle barons became just a memory. Eventually, the Industrial Club, the precursor of the Cheyenne Chamber of Commerce, bought the building, seen here, for office space. The chamber used the building until 1936, when it had it demolished. (ARC.)

THE RISE OF THE SHEEP BUSINESS

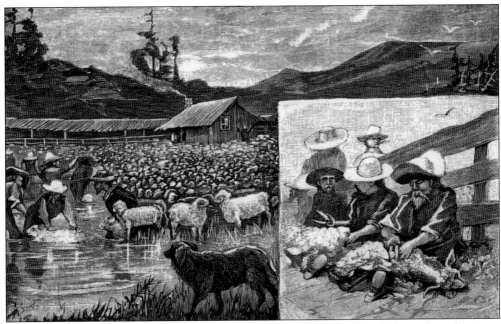

Cattle ranching was not the only game in town. Wyoming also developed a huge sheep business, and sheep far outnumbered cows for many decades. In his 1880 book *The Beef Bonanza; or, How to Get Rich on the Plains*, author James Brisbin touted the easy profits to be made from a small investment in sheep. Like cattle, sheep grazed the free range of the wide-open spaces. The industry grew rapidly during the 1870s, and then even more after the disastrous 1886–1887 winter. At its peak in 1910, the state had over 5.5 million sheep. (Brisbin.)

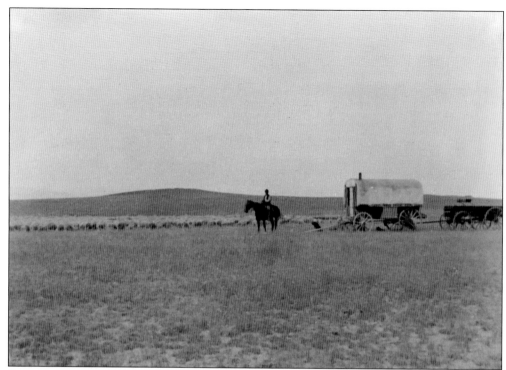

For many years, Wyoming ranked as the second-largest sheep-producing state, behind Texas. Pictured is the solitary work of a sheepherder. (AHC.)

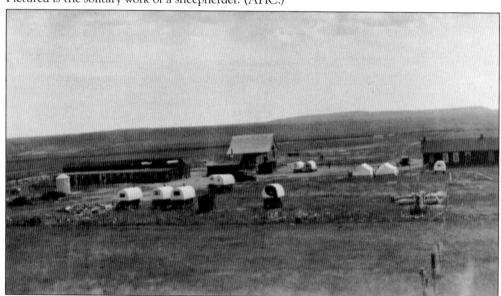

The Swan Land & Cattle Company entered the sheep business in 1904 and sold off its cattle in 1910. At the peak of Wyoming's sheep business, the company sheared about 112,000 sheep, which produced one million pounds of wool. One account recorded in My Life on the Range claimed that the Swan Company "was reported to be the largest single producer of wool in the United States" for a time. Herders lived in sheep wagons like the nine parked at the Swan shearing pens in this image. (AHC.)

In 1871, Francis E. Warren, later elected as Wyoming's first governor and then to the US Senate, founded what became known as the Warren Livestock Company and purchased both cattle and sheep, as did many early cattle barons. Warren's operation eventually controlled 284,000 acres of land and ran 110,000 sheep. The company, like many other large ranches, fenced public land, a practice that effectively excluded homesteaders. Congress made it illegal in 1885. The illegal fencing charge haunted Warren's long national political career. These two photographs, taken in 1996, are of a Warren Livestock sheepherder from Chile. (Both, RC.)

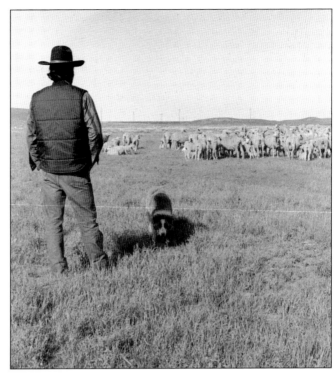

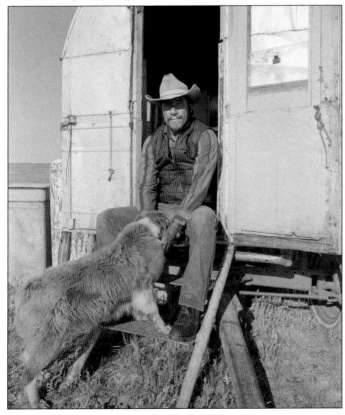

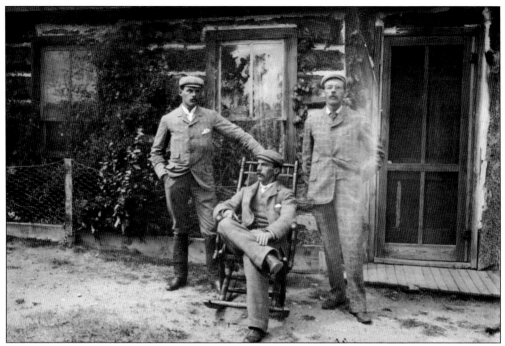

The King Brothers Ranch, located on the plains north of Laramie, became one of the most famous sheep producers in Wyoming. Seen above from left to right, Frank, Bert, and Joe King emigrated from England in the 1880s. Each first worked as a sheepherder, and they established their joint operation in 1904. The ranch eventually encompassed 120,000 deeded and leased acres. They became well-known nationally and internationally because of their sheep breeding program. At one time, their herd numbered over 12,000 sheep, and they exported sheep all over the world. In 1916, Frank King sold his share of the ranch to his brothers. Following Joe King's death in 1949, the company sold the ranch in 1950. The photograph below shows the King ranch house. (Both, AHC.)

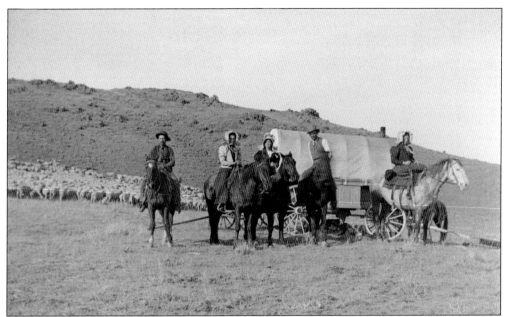

The sheep wagon became essential to the western sheep business. Unlike cattle, sheep need a person to watch over and protect them from predators. They also have a tendency to bunch up and potentially smother themselves to death during severe storms. Sheep ranchers, who often got their start as sheepherders, hired herders to trail their flocks over the many miles traversed during the yearly grazing cycle. The sheep wagon became the herder's home, and a horse or two usually moved the wagon every week or so to new grazing grounds. In the summer, a herder's wife and children might also live in the wagon with him. The Studebaker Wagon Manufacturing Company, at one time the largest wagon producer in the world, manufactured sheep wagons for many years that ranchers could order from a catalog. Some herders welcomed visitors, as shown photograph above. An unidentified woman is shown on horseback, with a rifle, in the photograph below. (Both, AHC.)

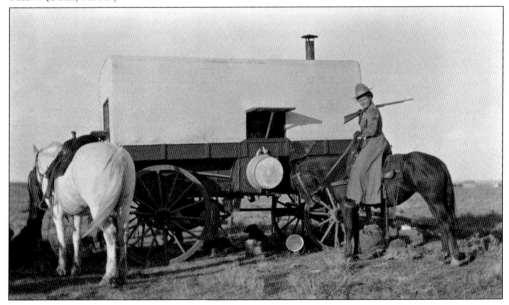

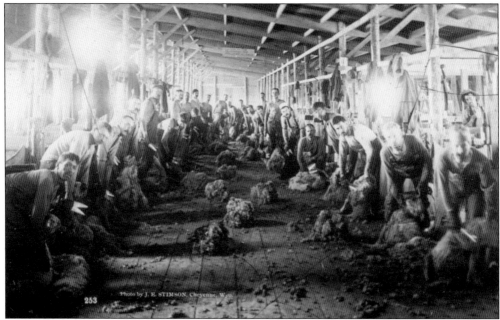

Shearing occurred during springtime and, in the early days, usually took place on the open range with little equipment, just a pair of shears, pens to hold the sheep, and perhaps a rough shelter. Due to cold, wet springs, the shearing operation moved to sheds, some constructed specifically for that purpose, which might be shared by a number of sheep outfits. While a small sheep rancher might hire a few local men adept at shearing, large outfits paid professional shearers. The shearing crews often traveled a circuit throughout a region, returning to the same ranches each spring. In 1903, sheepshearers in the western states organized a union headquartered in Butte, Montana. Over 1,000 shearers became union members during the peak years of the industry. These two photographs show a large shearing crew (above) and a smaller one (below). (Both, AHC.)

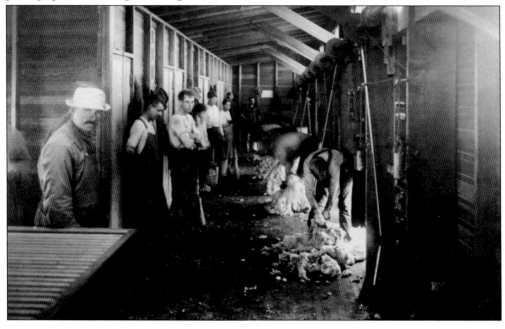

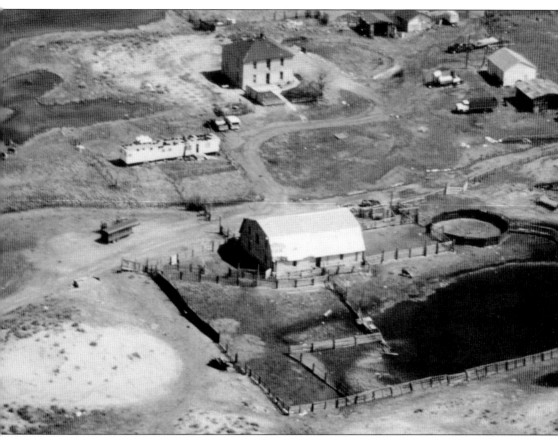

Danish immigrant Isaac C. "Ike" Miller became the first large-scale sheep rancher in Carbon County, which eventually ranked as Wyoming's largest wool-producing area for many years. He arrived in Wyoming in 1867 as a 23-year-old construction worker for the Union Pacific Railroad. Miller began buying cattle in 1873 and added sheep two years later. His partnership in a sheep ranch with Joel Hurt ended in 1888 when they split their herd, with Miller keeping the I Lazy D Ranch, shown in this aerial photograph. (MM.)

Miller built a stone house and barn in 1890, and they both still stand today. Because of their need to constantly resupply their herders from a local mercantile, more sheep ranchers than their cattle counterparts chose to live in towns, where, like Miller, they also built large houses. Ike Miller died in 1912, but his son Kirk Miller and then his grandson Frank Miller managed the sheep ranch until 1973, when they switched to cattle. The ranch is still in operation today. Frank Miller is shown with the house behind him in this photograph. (MM.)

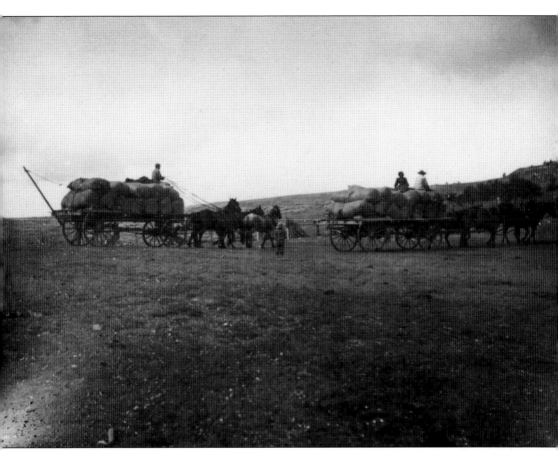

Wyoming's huge livestock industry could not have developed as it did if not for the completion of the first transcontinental railroad in 1869, which opened the western territories to the distant markets of the East and West Coasts. The Union Pacific Railroad wielded tremendous political and economic power and traversed the southern part of the state. The company freighted Wyoming's cattle to Omaha stockyards and wool to Boston warehouses. This photograph shows wagons hauling King Brothers woolsacks to the nearest rail yard. (AHC.)

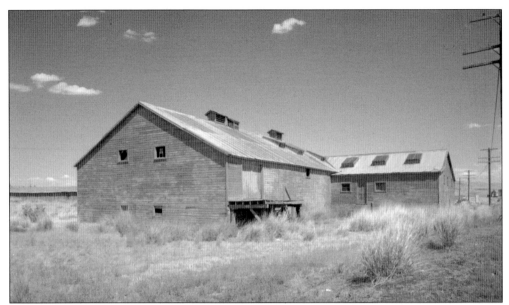

In 1915–1916, a number of Wyoming sheep men experimented with new methods of wool preparation based on the progressive Australian system, which included the introduction of a new type of shearing shed. At least 18 Australian-style sheds were constructed in the state; most sat alongside or close to a rail siding so the baled wool could be loaded directly onto freight cars. The large modern sheds could accommodate 20 or more shearers and were designed to use newly introduced machine shearing methods that claimed to be faster and smoother with less risk of injury to the sheep than the handheld shears. The interior of the Walcott shed featured numbered chutes through which freshly shorn sheep descended to the counting pen below the main floor. The exterior of the Walcott shed is shown above and the interior below. (Both, RC.)

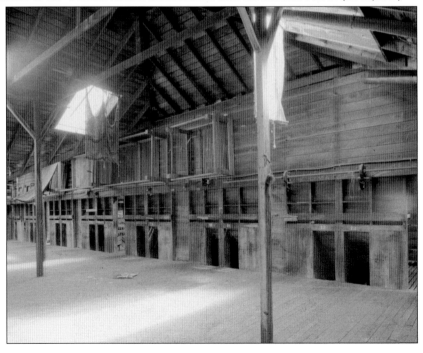

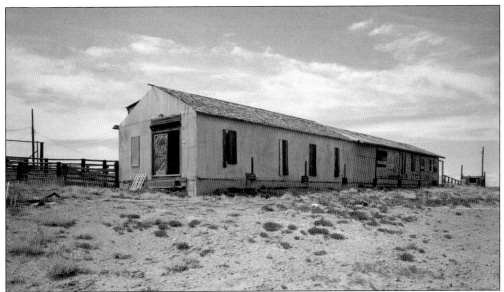

Depending on the number of sheep, a shearing crew might work at one shed for three weeks. In 1916, *National Wool Grower* reported that rancher William Daley erected a galvanized iron bathhouse with three porcelain bathtubs that were used by his shearing crew. "The men all seem to appreciate his kindness," the report read. Shearers often left their signatures, a date, and drawings on the shed walls, as seen below on the Daley shed. Although it was not built in the Australian style, Daley did locate his shed beside the Union Pacific tracks west of Rawlins. The Australian-style sheds continued to be used as shearing centers, although the installed machinery never gained popularity and was removed. Over the years, many of them burned down or were demolished. The photograph above shows the Daley shearing shed. Below is an interior wall with graffiti left by the shearers. (Both, RC.)

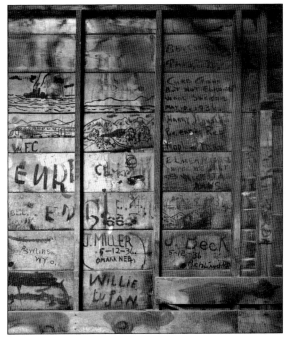

WYOMING

SPRING CREEK RAID
APRIL 2nd, 1909

Cattlemen of the Big Horn Basin dominated the range for many years and set up boundaries or "deadlines" where sheep were forbidden. Fierce animosity grew between the opposing sheep and cattle ranchers as several sheep camps were raided during the late 1800s and early 1900s.

In late March, 1909, Joe Allemand, a French sheepman, and Joe Emge, a cattleman turned sheepman, left Worland headed for Spring Creek with 5000 head of sheep. They were accompanied by Allemand's nephew, Jules Lazier, and two sheepherders, Bounce Helmer and Pete Cafferall. Talk spread like wildfire across the western slope of the Big Horn Mountains as the deadline was crossed and plans were soon made to head off this intrusion.

On the moonlit night of April 2, 1909, seven masked riders approached the sheep camp's two wagons where the herders slept. Gunfire lit the night as rifles blazed. Emge and Lazier were killed in their wagon and both wagons were set afire. Allemand emerged from the flames, but was quickly shot down.

The monument on this side of the road is situated at the site of the south wagon. The monument on the north side of Spring Creek is near the location of the wagon where the sheepmen were killed. Five of the perpetrators were convicted and sent to prison. Public reaction against this brutal and tragic act left no doubt that violence on Wyoming's open range would no longer be tolerated.

Most of the clashes between cattle and sheep ranchers over who could use Wyoming's free range occurred during the first two decades of the 20th century. Tension between the groups escalated as sheep began to graze the public land traditionally used by cattlemen, who viewed the sheep ranchers as latecomers. In the 1909 Spring Creek raid, masked men murdered two sheep ranchers and a herder, burned sheep wagons, and killed the sheep. In 1934, the federal government, by law, gained total control of the remaining public domain, which finally closed the open range. This interpretive sign that describes the raid is located south of the town of Ten Sleep. (RC.)

Seven

OTHER NOTABLE RANCHES

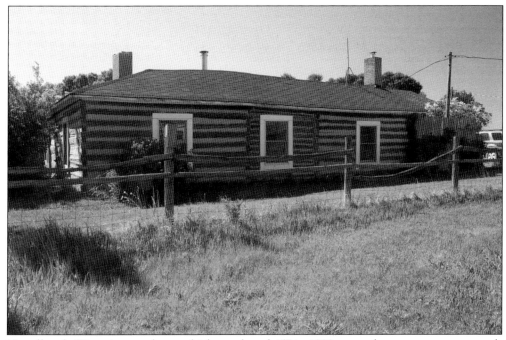

Not all early Wyoming ranches—which numbered 457 in 1880—were huge, open range spreads owned by cattle barons. Some ranch buildings, like the main residence on the Richardson Overland Trail Ranch, preceded the establishment of the cattle industry. The oldest part of the house was constructed some time before 1862, when the Overland Trail opened and passed through the property. An 1869 map noted the house as a stage station run by Tom Alsop. This photograph shows the early log walls of the stage station. (RC.)

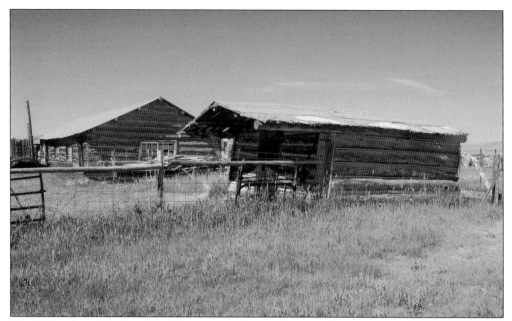

The Richardson Overland Trail Ranch is still a working cattle operation today. A later owner hoped to attract dudes and moved three log buildings to the property. Two of the log buildings are shown above. (RC.)

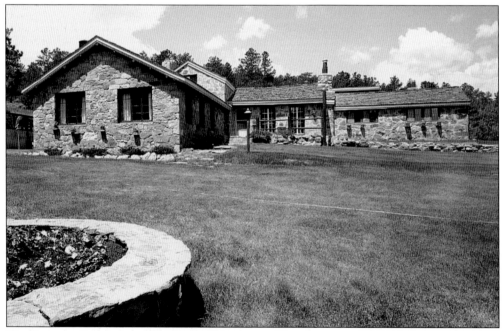

The Remount Ranch, located between Cheyenne and Laramie, is most notable for its connection to author Mary O'Hara, who wrote *My Friend Flicka*. O'Hara purchased the Remount in 1930, and she and her husband enlarged the original 1886 pink granite house, raised sheep, and bred polo and cavalry horses. She also wrote *Thunderhead, Green Grass of Wyoming*, and *Wyoming Summer* while living at the ranch, which she sold in 1946. The enlarged ranch house is shown here. (RC.)

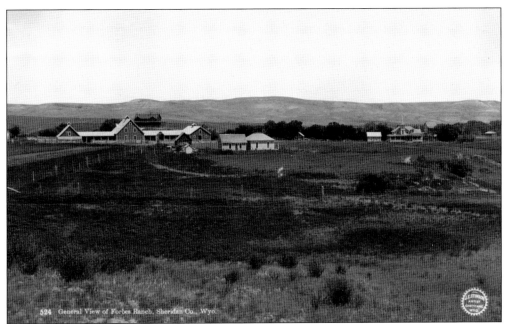

In 1898, William Hathaway Forbes, a former ambassador to Japan, and his two brothers, Edward and Alexander, purchased a ranch at the foot of the Big Horn Mountains. The property had been homesteaded in 1878 by George Beck, who helped Buffalo Bill develop the town of Cody. Beck built a large house at the ranch in the 1880s, which was moved in 1905 to its current location on the Beckton Stock Farm, as the ranch is formally known. Until 1930, the ranch raised Rambouillet sheep and registered Clydesdale horses. The overview image above of the ranch was taken by noted photographer Joseph Stimson. The large sheep barn, constructed in the 1920s, is pictured below. (Above, ARC; below, RC.)

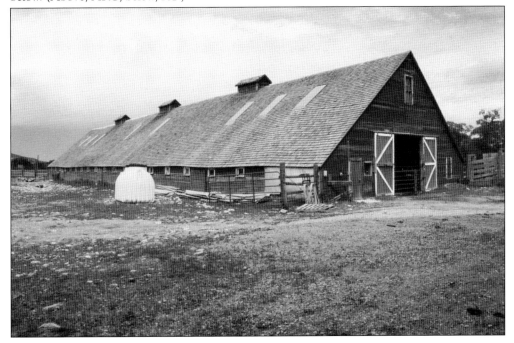

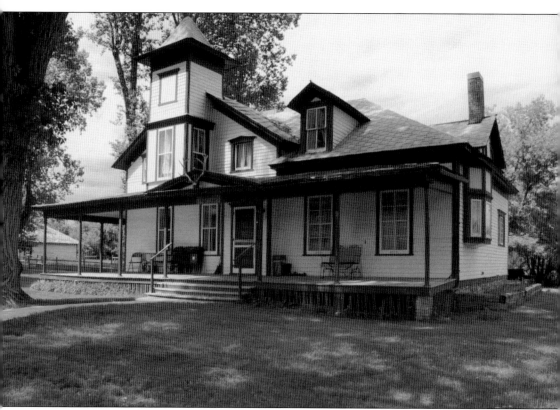

In 1939, William Forbes's nephew Waldo Emerson Forbes and his wife, Sal, made the ranch their full-time home, which none of the family had done before. Waldo expanded and modernized the ranch and recognized the need for more efficient beef production based on scientific testing and genetics. In 1945, he became a pioneer in developing Red Angus cattle, now an official breed, and formed his first herd. His sons Cam and Spike run the ranch today and raise the largest Red Angus herd in the country. The old ranch house that Beck built, seen here, has served as the office for many years. (RC.)

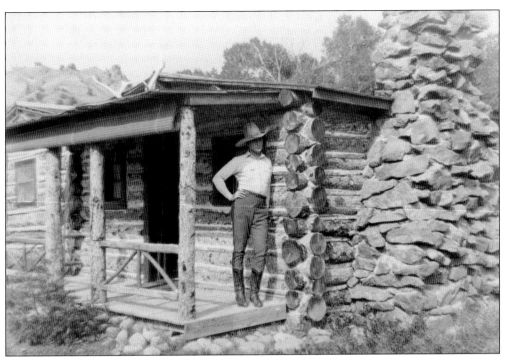

Tim McCoy was born in Michigan and made his way to Wyoming as a young man, where he worked as a cowboy and also learned sign language from the Arapaho Indians living on the nearby Wind River Reservation, who named him "High Eagle." He established his ranch, Eagles Nest, in the Owl Mountains near Thermopolis and maintained it for over 30 years. McCoy became a popular Hollywood actor in the 1920s, when he starred in many western movies of the silent era. His colorful life included Army service in both world wars, a stint with the Ringling Bros. Circus, a television show, and even a run for a US Senate seat representing Wyoming. McCoy died in 1978 at the age of 86. Both of these photographs show McCoy at his ranch. (Both, AHC.)

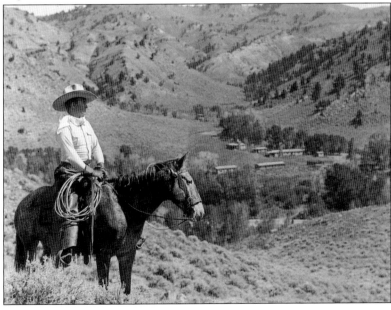

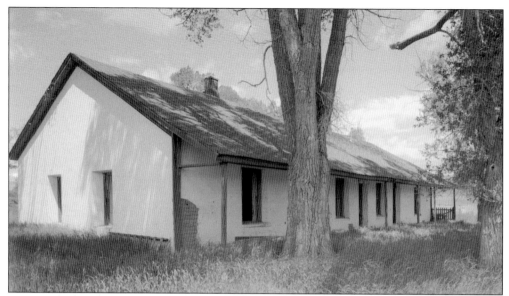

Count Otto Franc von Lichtenstein visited northwestern Wyoming, an area with few white settlers, on a hunting trip in 1877–1878. In 1880, he established the Pitchfork Ranch along the Greybull River. His adobe brick house, seen here, was constructed that same year and covered with stucco. He stocked his ranch with Texas cows and Oregon Herefords and, by 1889, had 6,000 head. Von Lichtenstein's death in 1903 by a gunshot wound remains a mystery, but many believe he was murdered due to his conflicts with local sheep men. (RC.)

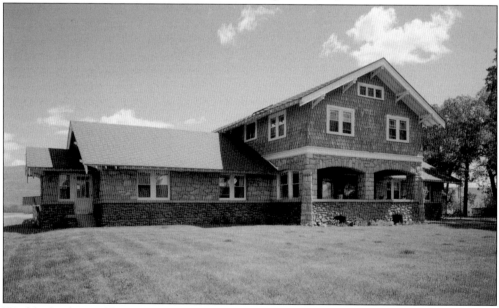

Wealthy banker and businessman Louis Graham Phelps began building a ranching empire near present-day Meeteetse when he purchased von Lichtenstein's Pitchfork Ranch, the Z-T Ranch, and others in 1903. His entire ranch eventually totaled 250,000 acres; it became known as the Pitchfork and always used the Pitchfork brand. At different times, the Pitchfork ran as many as 20,000 cows and 60,000 sheep. The Phelps family moved to a new ranch house, constructed in 1918–1920, when their earlier log house burned down. The new ranch house is seen here. (RC.)

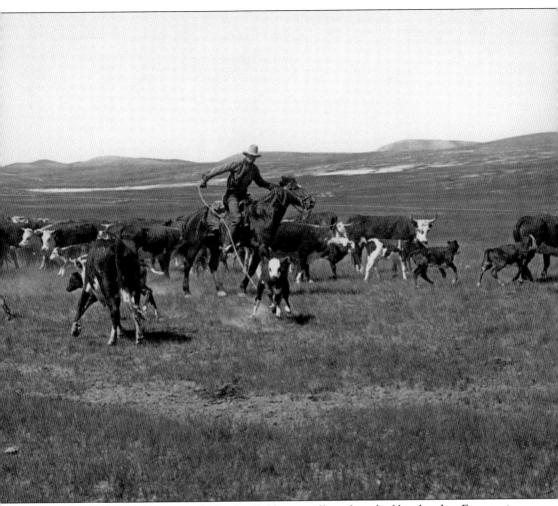

Phelps's daughter Frances married Charles Belden, a college friend of her brother Eugene, in 1912. Upon the death of Louis Phelps in 1922, Eugene Phelps and Charles Belden tried to run the Pitchfork together, but both had other interests. Belden later became known as one of the most famous photographers of the west, and the Pitchfork Ranch, which also operated as a dude ranch for a number of years, served as the setting for many of his iconic images. (ARC.)

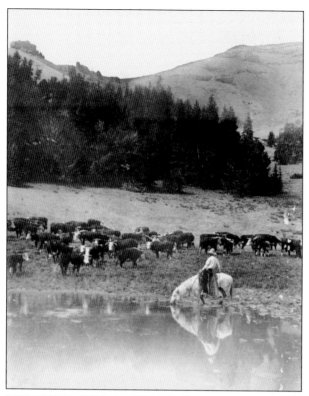

Charles Belden's images from the 1920s and 1930s helped popularize and romanticize the west and make the Pitchfork Ranch a famous dude ranch. His photographs appeared in newspapers around the country, *National Geographic* magazine, calendars, books, and museums. Belden left the Pitchfork in 1940 and moved to St. Petersburg, Florida, where he photographed motels, tourist destinations, bathing beauties, and other subjects for advertisements, but those images never achieved the success he had with his western photographs. Belden committed suicide in 1966. A museum in the town of Meeteetse, located near the Pitchfork, operates today and features much of his work. The Phelps family heirs sold the Pitchfork in the 1990s, and it remains a cattle operation today. (Left, ARC; below, AHC.)

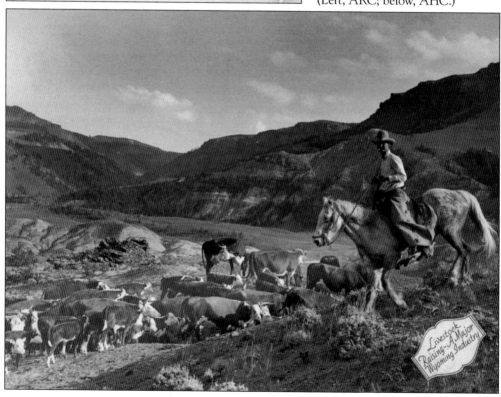

Eight

HOMESTEADING IN WYOMING

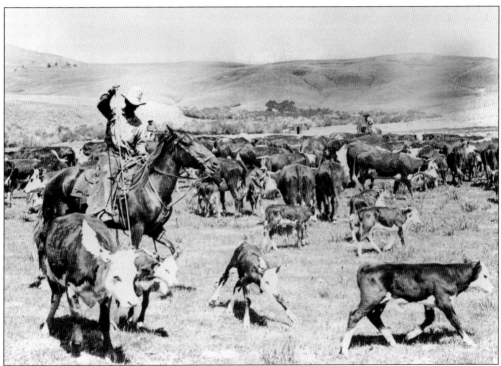

Brothers Bill and Tom Duncan came to Wyoming from Scotland in the 1890s. They settled in the East Fork area of Fremont County, and two other brothers joined them a few years later. They all began "proving up" homesteads in an area that became known as "Little Scotland." The ranch produced cattle, sheep, and hay. Bill's daughter married into the Finley family, and her husband joined the Duncan family business. This photograph shows cowboys roping cows on the ranch. Although much of the ranch has been sold, the original East Fork homestead site remains in the Finley family. (SHPO.)

The 1862 Homestead Act allowed any US citizen at least 21 years old, including freed slaves, to acquire 160 acres of the unclaimed public domain as long as that person lived on the land for five years, erected at least a 12-foot-by-14-foot building (often known as a homestead shack), and planted crops. Later amendments added more land, depending on the location and the availability of water, and lowered the residential requirement to three years. These acts encouraged settlement in the large western territories. This photograph shows the Ulysses S. Grant homestead shack in Converse County. (RC.)

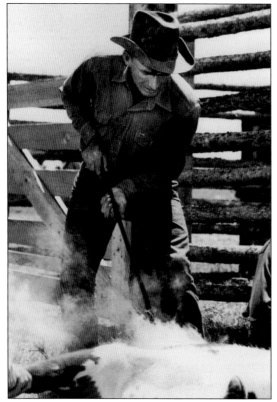

The Teapot Ranch, in Natrona County, took its name from a huge rock formation that resembled a teapot. Grace Gordon and John Beaton married in 1911 and combined various family homesteads to form their sheep business. In the 1930s, the family added cattle and gradually decreased the number of sheep. In this photograph, Grace and John's oldest son, Johnny Beaton, brands a Hereford calf, before the family switched to Angus cattle in the 1950s. (SHPO.)

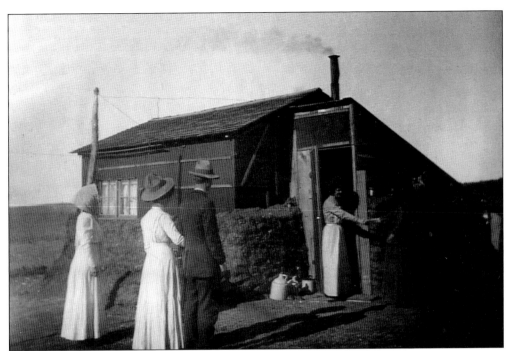

Carl Bruch established his homestead adjacent to those of his older siblings. The homestead shack is shown above. The photograph at right shows Bruch driving a square-turn tractor on his farm and cattle ranch in Niobrara County in 1910. According to the tractor manual, the machine, built in Norfolk, Nebraska, could turn a square corner in five seconds. Bruch, an inventor and machinist, often helped neighboring ranchers. He built windmills from a Ford Model T and a shed out of cyanide cans he salvaged from the Homestake Mine in Lead, South Dakota. One of the old ranch buildings serves today as a museum dedicated to Bruch. (Both, SHPO.)

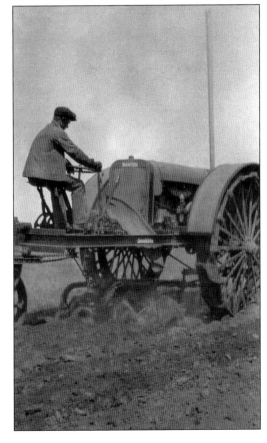

O.W. Hall, his wife, Melinda, and their children Cora, Lora, and Ernest traveled from Nebraska to Wyoming in 1901. They intended to settle in Montana but were convinced to stay in the Wildcat Creek area near Gillette. They homesteaded, and their land formed the basis of the Hall Ranch. By 1910, Ernest managed the family ranch business. He and his wife, Joy, raised cattle and cavalry remount horses. In 1949, their son Dean and his wife took over the ranch, followed by their children assuming the reins in 1980. The ranch has stayed in the Hall family for over 100 years. These photographs show branding on the ranch in the 1930s. Ernest, Dean, and the hired hand surround a cow during branding. (Both, SHPO.)

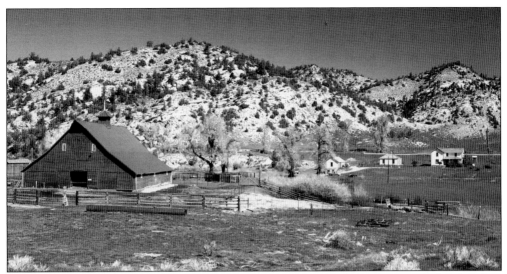

The Henry Renner family came west from Tennessee and traveled the Oregon Trail to Condon, Oregon, where they homesteaded in 1890. In 1897, George Renner and his cousins trailed 6,000 Oregon sheep to Wyoming's Big Horn Basin, where they established homesteads and purchased property along Gooseberry Creek near Meeteetse in Park County. The George Renner family continued in the sheep business until the late 1940s, when they converted to a cattle operation. The fourth and fifth generations of the George Renner family continue to run the ranch, which is seen here on Gooseberry Creek. (RC.)

In 1901, Margaret Rabou and her son George purchased land west of Cheyenne. Because of water issues, they moved east in 1905 to homestead and purchase land for a ranch near Albin. They spent their first winter living in a tent on Bushnell Creek, and eventually, George built a two-story house, which their descendants still occupy today. This photograph shows George Rabou wearing woolly chaps in 1913. (SHPO.)

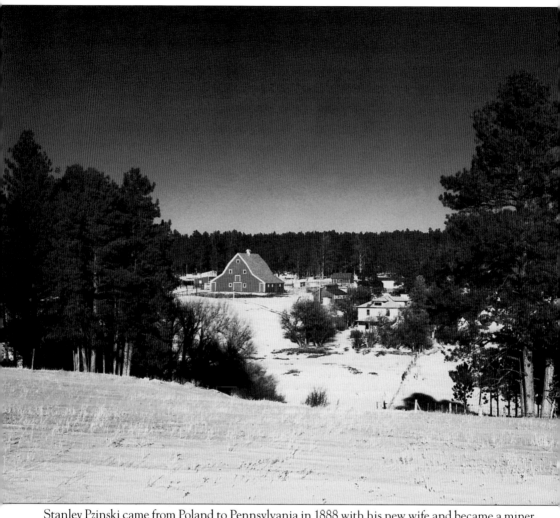

Stanley Pzinski came from Poland to Pennsylvania in 1888 with his new wife and became a miner. In 1902, they moved to Cambria, Wyoming, looking for a better life. Stanley worked in the mines while homesteading near Newcastle. On weekends, he walked 17 miles to the homestead to clear the land. The large barn, constructed in 1912, was built with 50 kegs of nails. Today, the Pzinski Ranch, seen here, is a cow and calf operation run by the fourth generation of the family. (RC.)

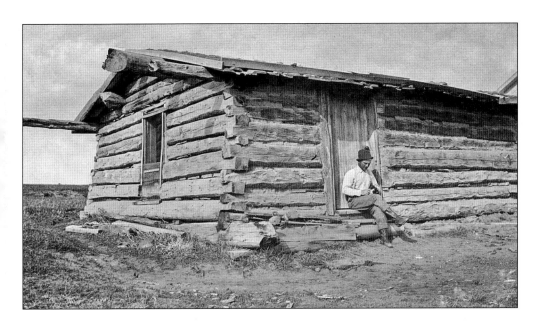

In 1906, William and Gertrude West moved to Crook County from Nebraska. William taught school in a small country schoolhouse and also milked cows and freighted to South Dakota using horse-drawn wagons. The family, including their six children, homesteaded in the northwest corner of Crook County and established a sheep ranch. They gradually enlarged the house to fit the growing family. The West Ranch switched to cattle in 1994, and hay is also grown on the ranch today. (Both, SHPO.)

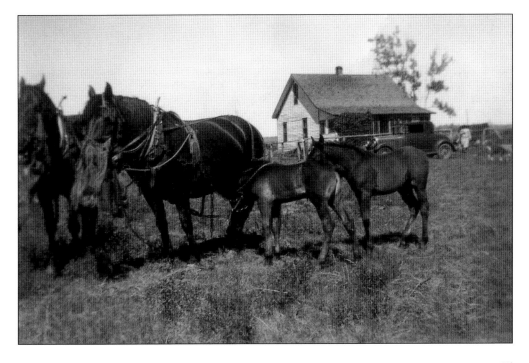

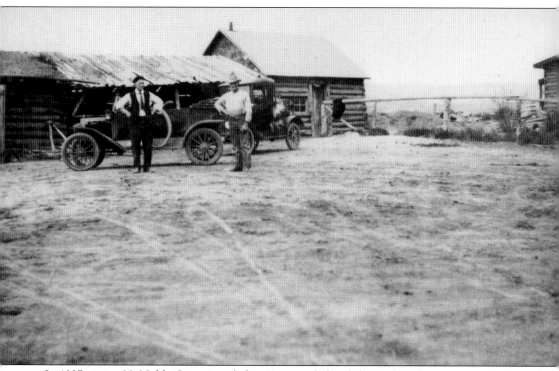

In 1897, at age 20, Noble Graves settled in Barnum, behind the Red Wall country at the foot of the Big Horn Mountains. By 1901, his parents and siblings had joined him, and most filed on their own homesteads in the area. Noble formed a ranching partnership with his father, Charlie, and his brother Frank, and they ran horses, cows, and sheep. The brothers split the ranch in 1941 when Charlie died. Noble Graves collected metal remnants from the nearby Dull Knife Battlefield to make tools, parts, and equipment for the ranch. The fifth generation of the Graves family still runs the ranch today, which is not far from the Hole-in-the-Wall, where Butch Cassidy, the Sundance Kid, and other outlaws hid out. The Noble Graves homestead is pictured here. (SHPO.)

In 1910, cowboy Frank Prager and his new wife, Ellen, arrived in their Studebaker buggy at the land that became the Prager Ranch in northern Albany County. They began married life in a two-room cabin and, over the years, acquired multiple homesteads in the area. By 1922, the family moved to a new two-story house with four bedrooms (right) built on Frank's original homestead. They logged the trees on their mountain land to build the house and two barns (below). The ranch did not own a tractor to mow hay until 1956. The Prager Ranch is now over 100 years old and is still run by the family. (Right, SHPO; below, RC.)

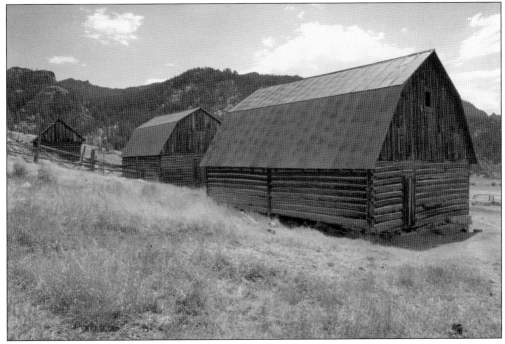

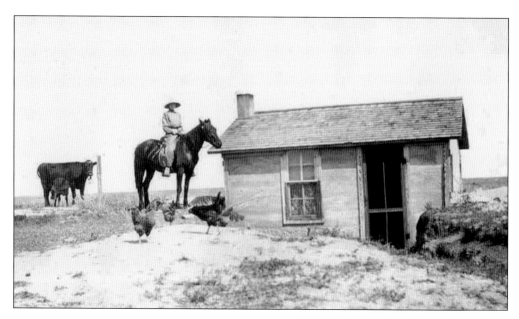

J.C. Berry and Mary Bevan each homesteaded on land 20 miles north of Cheyenne in the early 1900s. Bevan's homestead shack is pictured above. They met at a pie social and married in 1914. J.C. and Mary had four children and bought their first Hereford cows for a 4-H project in the 1930s. With those cows, they built a registered herd that produced many champions. J.C. and his sons Jim, D.C., and Marvin, pictured below, formed a partnership in 1946 that lasted until Jim retired in 1980. Like many family ranches, the Berry Ranch was divided between two branches of the family who continue to run both ranches today. (Both, SHPO.)

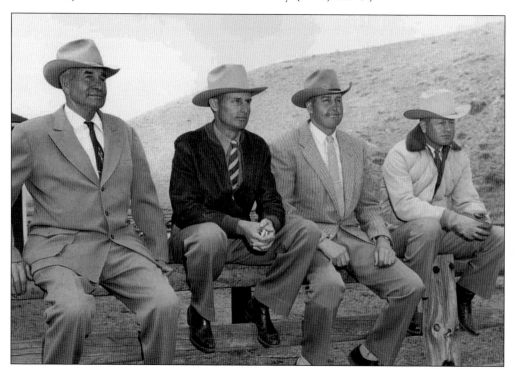

In 1886, Ulysses "Uly" S. Grant and his two brothers traveled from their Iowa home to Wyoming to homestead in Upper Boxelder, in Converse County. Over time, Uly acquired additional homesteads when neighbors sold out. Local residents often repeated the story that Uly thought the ranch was so nice in the summer that he did not want to leave and so bad in the winter that he could not leave. Commercial electricity reached the ranch in 1956 and party-line telephone service in 1968. Uly and his brother Charles worked together for many years, and a number of their descendants still ranch in the Boxelder area. Charles established the Grant Ranch, where the big red barn is a local landmark. The photograph above shows Ulysses Grant with his children. Charles Grant's son Fred is pictured at right ready to go to work on the ranch. (Both, SHPO.)

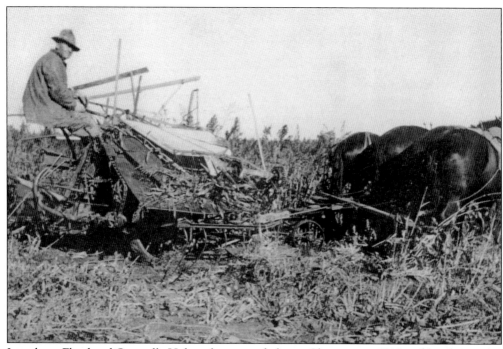

Iowa-born Floyd and Georgella Holmes homesteaded near Cheyenne in 1910 and lived in a two-room shack. Floyd worked multiple jobs on neighboring ranches and worked on his homestead as well (he is seen haying above). Georgella raised chickens and turkeys, which she sold in town along with butter and eggs. In the early days, she had to haul water from a nearby ranch (below). By 1925, the Holmes family had acquired more land and began running cattle. The also built a new house along the Yellowstone Highway. For decades, the Holmes family was very involved with Cheyenne Frontier Days, and various members served as parade marshals and rodeo queens in the annual celebration of the Old West. (Both, SHPO.)

Robert Grant and his son Duncan emigrated from Scotland in the 1860s. They homesteaded on Sybille Creek in Platte County. To help earn cash for the family, Duncan freighted supplies from Cheyenne to Fort Fetterman and Fort Laramie for a number of years. He then worked for the Swan Company for over 20 years, where he eventually became cattle foreman over all the company ranches. Duncan (above left) left the Swan Company when it switched to a sheep operation, and he then focused his attention on the family ranch, where he developed the first apple orchard in Platte County. The two-story Grant ranch house (below), completed in 1890, has been the home of Duncan's granddaughter and her husband for many years, and their children now run the cattle ranch. (Both, SHPO.)

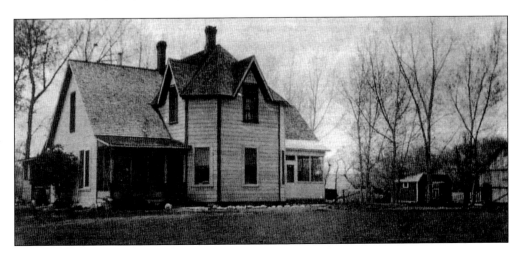

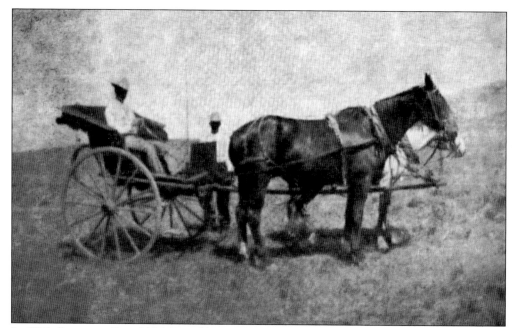

In 1876, Scotsman Donald McDonald moved to Wyoming from Canada and worked on sheep ranches for five years before homesteading on Chugwater Creek in Platte County. He expanded his holdings to over 3,000 acres and built a two-story rock house in 1890 for his wife and four children, who are pictured below on the car with Donald and other friends. Their son Hugh married a local teacher, Rissa McCann, who handled the ranch business and purchased nearby small ranches to add to the home ranch. In 1956, Rissa bought the Diamond Ranch, where eccentric cattle baron George Rainsford had raised thousands of horses in the 1880s. Any photograph of Rainsford, including the one of him above in a carriage, is rare. Hugh and Rissa converted the Diamond Ranch into a guest ranch that operated from 1968 until 2005. Today, McDonald descendants live and ranch on the property. (Both, SHPO.)

Fred Christensen came to Wyoming from Michigan in 1902 and worked on ranches before he homesteaded on Pumpkin Creek in Campbell County in 1907. Originally, he ran sheep on his land, but he switched to Hereford cattle in 1929. The photograph above shows the original Christensen barn, and the photograph below shows the wool clip being hauled to the railroad in Gillette in the late 1920s. Like many other homesteaders, Fred expanded his ranch by buying local homesteads. He married Ellen Brown, a schoolteacher, in 1918. She taught school to her children and a neighboring girl in a ranch bunkhouse for three years. Today, C-J-R Christensen Ranches operates in three states and employs over 20 people. (Both, SHPO.)

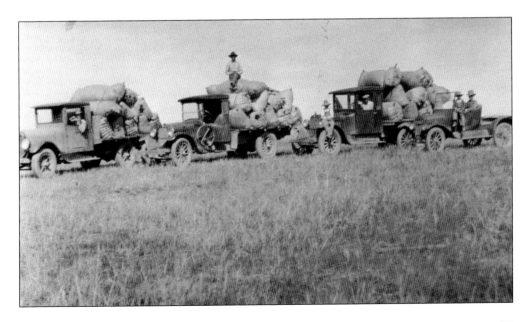

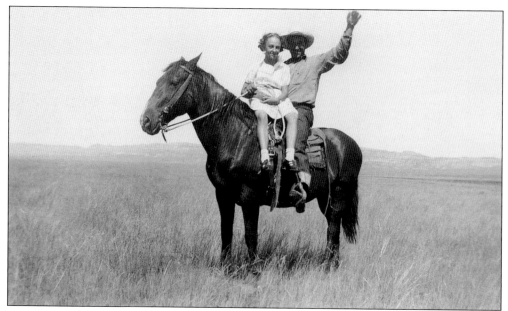

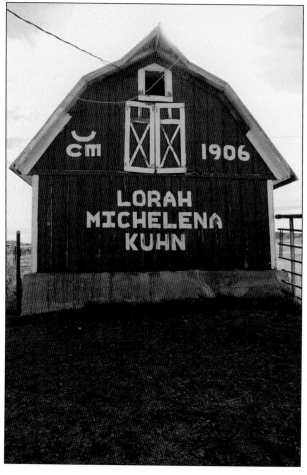

Alva and Maggie Lorah homesteaded near Cottonwood Creek in Sheridan County in 1906, where they raised 10 children. Their daughter Ethel married a Basque sheepherder, Santiago Michelena, in 1924. In the late 1920s, the Lorah family sold their land to Ethel and Santiago, who ran sheep and cows along Powder River for over 50 years. Their two daughters continued to ranch the family land in Sheridan and Johnson Counties after their marriages. Candida, pictured above on a horse with her father, Santiago, married Al Kuhn, who worked with her father, and Margaret married John Gammon, the owner of the TA Ranch, where the Johnson County War had taken place. Like many ranches today, the family ranch is currently leased out, but Lorah descendants still own and manage it. The barn (left), built in 1906, displays family names and the brand. (Above, SHPO; left, RC.)

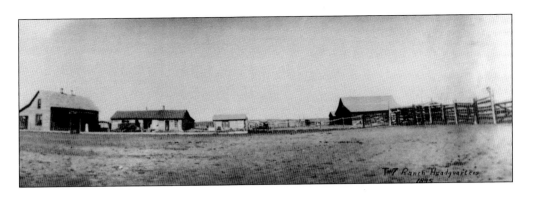

Texas cattleman T.N. Matthews drove his cows to the open range of northern Wyoming in the late 1870s, a trip that lasted 60–80 days. The first winter nearly wiped out the herd, but Matthews made a second drive from Texas to Campbell County, where he established the T7 Ranch (above). The first ranch buildings were constructed of logs in the late 1870s, but by 1882, Matthews used sawn lumber from the Sundance area to construct other structures. Because the open range was rapidly disappearing after the mid-1880s, Matthews convinced family members to prove up on numerous homestead claims near water so that the ranch could continue to raise cattle. The photograph below shows a T7 roundup in 1911. Today, over 130 years later, Matthews's great-grandson owns and manages the T7. (Both, SHPO.)

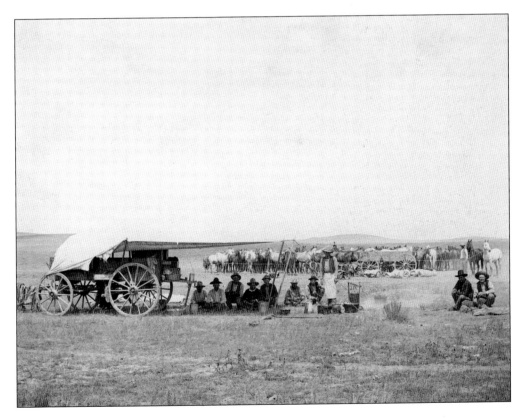

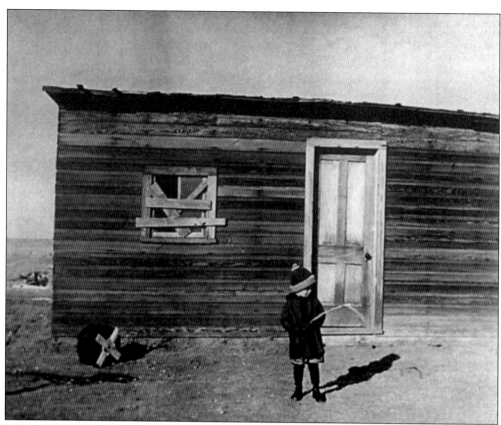

In March 1910, Elva Enix and her father, Calvin, traveled to Wyoming from Iowa and homesteaded adjoining land near Slater Flats in Platte County. They built a tar paper shack on the property line between the two homestead claims, and Elva slept on her land while her father slept on his. By 1911, Elva had her own house and taught school. She married John Mers, and when her family returned to Iowa, she and John stayed to raise their family on her homestead. During the Depression, the family grew farm crops, worked a large garden, and raised chickens for food. Elva's son is pictured above outside the homestead house in 1917. John Mers hauled wheat to market using his car. When their descendants celebrated the 100th anniversary of the property, they walked the boundaries of Elva's 320-acre homestead. (Both, SHPO.)

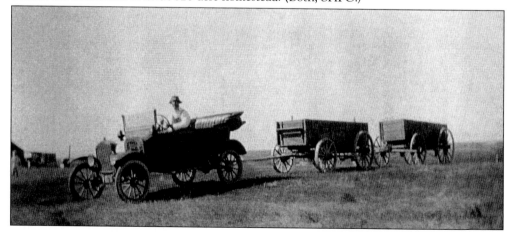

Samuel "Tilden" Hollcroft left home in Missouri and came to Wyoming in the late 1800s. He worked on several ranches and with the railroad, but he dreamed of having his own homestead. In 1901, he filed on land along Powder River in Johnson County when the original homesteader, known as Arapahoe "Rap" Brown, was murdered. Hollcroft improved Brown's cabin for the family home, which is pictured at right. He worked for ranchers for nine years to subsidize his homestead. He and his wife, Goldie, helped establish the first school in the area to ensure their three children received an education. Their son Leo later bought the ranch and built a 300-foot bridge across Powder River to make it easier to bring supplies to the isolated location. The family still uses it today on the ranch. One of the notable peaks above Powder River is named Hollcroft's Peak (below). (Right, SHPO; below, RC.)

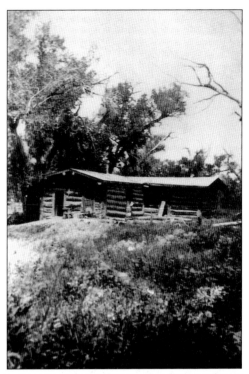

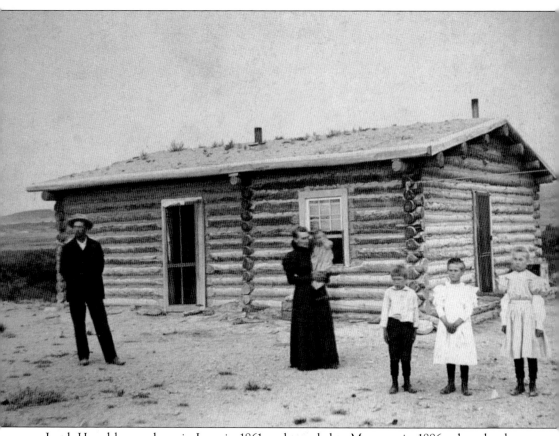

Jacob Herschler was born in Iowa in 1861 and traveled to Montana in 1886, where he drove a stagecoach for two years. He then filed on a homestead claim on Fontenelle Creek in Lincoln County and began to build a sheep ranch in 1888. The first home was a dirt-floored, three-room log house that received a number of additions over the years. He married Josephine Fuller in 1886, and they had four children. Twice a year, Jacob traveled 35 miles to purchase supplies at the nearest store, located in Opal. Ed Herschler, the son of Jacob and Josephine, became a lawyer for the town of Kemmerer and then Lincoln County's prosecutor. He also entered politics and was elected as Wyoming's governor an unprecedented three times (1975–1987). This photograph of the Herschler family shows the original homestead house. (Herschler family.)

The homestead house now has a second story. Ed Herschler's daughter continues to live in the homestead house, and she and her family run the ranch today. (RC.)

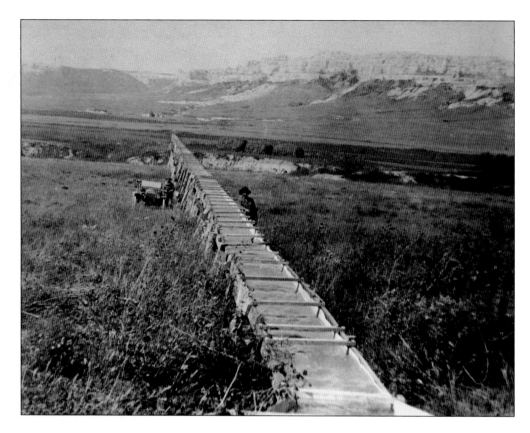

In 1904, Otis and Nancy Lovercheck traveled from Nebraska to the CP Ranch, near LaGrange in Goshen County. Otis purchased the old CP brand in 1909, and it is still displayed on the cattle barn. He believed in ranch diversification, and the family raised Hereford cattle, chickens, and pigs and grew wheat, barley, and alfalfa. Otis built a long flume (above) on the ranch to divert water to irrigate artichoke fields. Remnants of the flume can still be seen on Lower Bear Creek. During the Depression, Otis made monthly treks to Cheyenne to purchase coats and shoes for the men who traveled the country as hobos looking for work. The Lovercheck Ranch panorama below was taken in the 1940s. Today, four generations of the Lovercheck family live on the ranch. (Both, SHPO.)

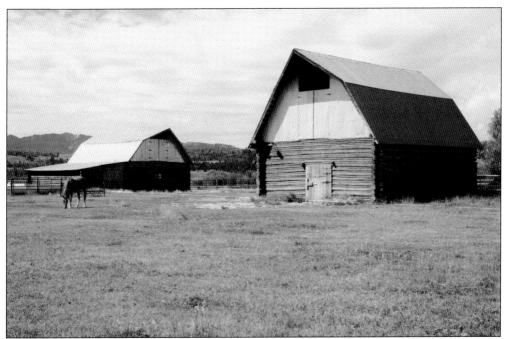

The Feux family, originally from Switzerland, came to Wyoming in 1911 and homesteaded on land that is now part of Grand Teton National Park. Feux did not want to sell his land to the National Park Service, but he eventually traded his 160 acres in the park boundaries for 600 acres in Sublette County, which is where he relocated the ranch. The family added more land over time. Walter Feux, along with his brother, built the horse barn in 1945 and the cow barn in the 1950s, which are both shown here. His four daughters inherited the ranch, known as the Diamond Cross, and they continue to run a variety of operations on it. (RC.)

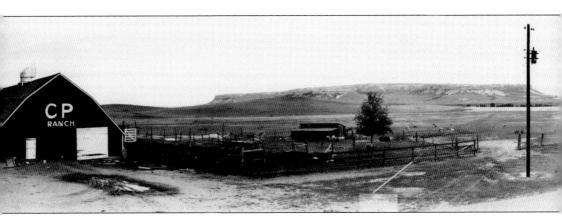

Phillip and Cinderella Yoder moved their family from Iowa to Cheyenne in 1881. By 1884, the family moved to a ranch on Bear Creek, near LaGrange in eastern Wyoming. After Phillip died in 1910, their son Frank continued to build and grow the 4A Ranch, as well as operate a number of successful businesses. He served as the mayor of Torrington and in the state legislature. A descendant of Yoder's owns the ranch today. The town of Yoder was named after the family, and the Yoder name still remains prominent in the area. The barn above was built from lumber from the 1893 World's Fair. (SHPO.)

Peter Svalina immigrated to America from Austria in 1907. He made his way to Wyoming and worked on several ranches and in the mines. Peter homesteaded near Sundance and continued to work as a miner while he got the homestead up and running. In 1928, he married Margaret Noonan, a schoolteacher who had the adjoining homestead (pictured above). Their five children grew up on the ranch and walked two or three miles to school in Hahn in addition to attending school in Margaret's original homestead house. Peter and Margaret's son Frank served in the Army in Fairbanks, Alaska, and eventually returned to continue ranching on the 15 Ranch. Margaret is pictured at right with her daughter Anna. (Both, SHPO.)

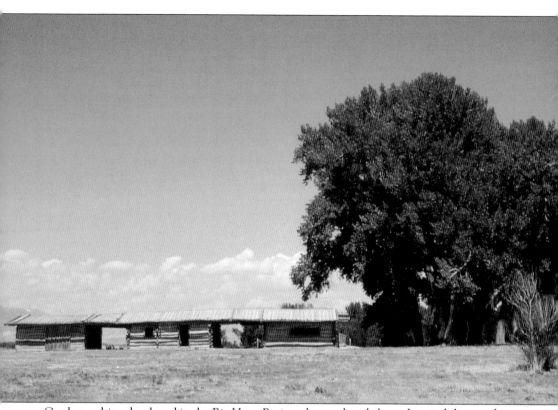

Cattle ranching developed in the Big Horn Basin at least a decade later than it did in southeastern Wyoming. In 1879, Henry Lovell, with the financial backing of Anthony Mason, trailed a herd of cattle from Kansas to the basin and became one of the large area's first ranchers. Mason and Lovell established the ML Ranch, where they ran 25,000 cows on primarily public and Crow Indian lands. The unusual bunkhouse, with two breezeways, was constructed at different times between 1883 and 1895. Lovell used the left one for his office and sleeping quarters. (RC.)

The lone cabin at the ML Ranch could be easily moved, as ranch buildings often were. The nearby town of Lovell was named after Henry Lovell. (RC.)

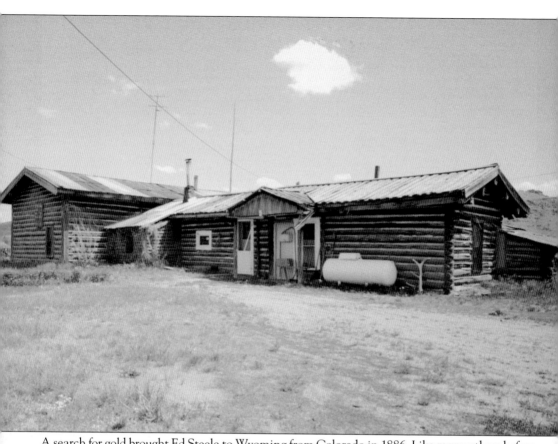

A search for gold brought Ed Steele to Wyoming from Colorado in 1886. Like many others before him, he did not find his fortune, but he remained in the area near Boulder. His wife and family joined him in 1888, and they acquired more land over time and eventually ran 600 head of cattle and 100 horses on their 3,000 acres. Many original homestead houses grew over time, and Steele's evolved from a one-room cabin constructed in 1886 to an eight-room house by 1908, as seen here, after it had been enlarged to accommodate the Steeles' eight children. (RC.)

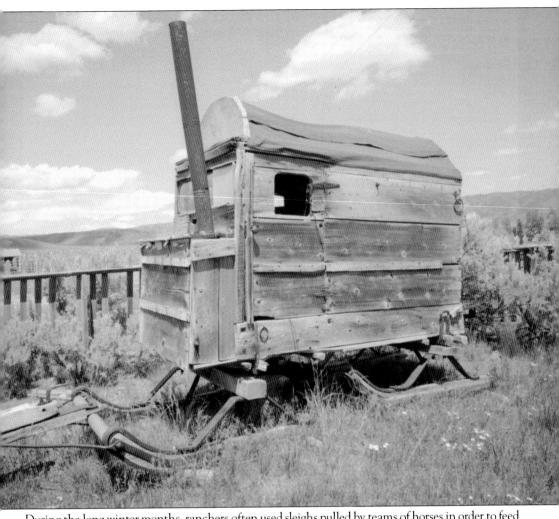

During the long winter months, ranchers often used sleighs pulled by teams of horses in order to feed their stock out on the range. The Steeles' unusual sleigh, shown here, even had heat. (RC.)

The Canadian-born George Cross came to Wyoming in 1875 as a 20-year-old cowboy and had purchased his own ranch by 1884. He became one of the most influential men in Converse County by 1900. Cross named his ranch Braehead after the home of his Scottish ancestors. The log cabin seen above after later additions served as the family's first home. Like many who ranched in unsettled areas, Cross contended with "wolves, thieves, Wyoming weather, insects, snakes, and other hazards." Following in the footsteps of other successful ranchers, Cross became a state senator and bank president. He had a much larger house built in the 1890s, and the Braehead was a social center for the area. A carpenter converted a former coal and tool shed into the Beaver post office (below), which operated on the ranch between 1887 and 1909. A number of Cross's nine children owned ranches in the area for many years. (Both, RC.)

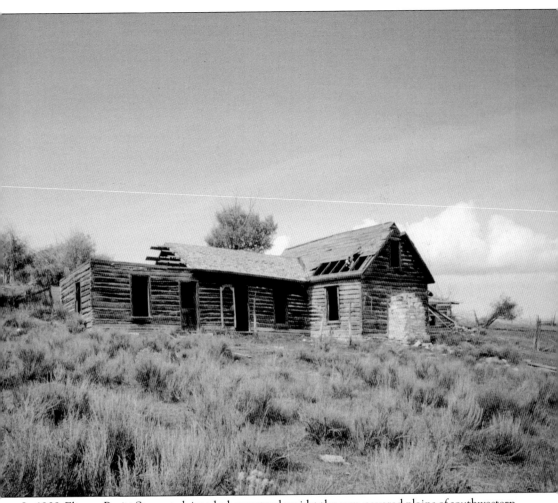

In 1909, Elinore Pruitt Stewart claimed a homestead amidst the sage-covered plains of southwestern Wyoming. She traveled to Green River to officially file on the land. In *Letters of a Woman Homesteader*, she described that journey: "In the whole sixty miles there was but one house, and going in that direction there is not a tree to be seen." Stewart's plucky tale of her homesteading experience is somewhat diminished by the fact that, shortly after her arrival, she married her employer, whose claim adjoined hers. Elinore Pruitt Stewart's homestead is pictured here. (RC.)

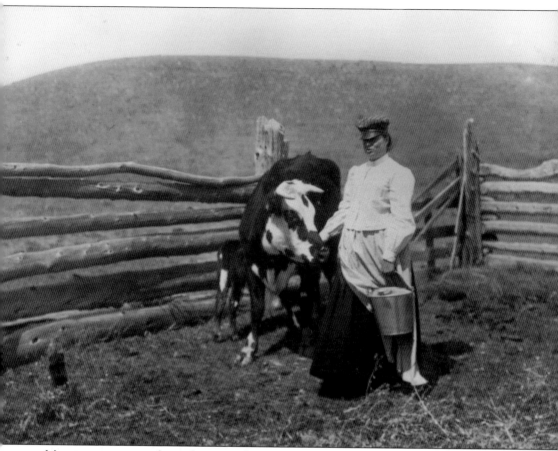

More representative of a single woman homesteader is the story of Frances Blake Smith, who left Chicago in 1920 to homestead near Gillette. In *Cow Chips 'N' Cactus*, she recounts the three years she spent proving up on her 640-acre claim. Each year, Smith stayed at the homestead for six months and then returned to Chicago to work and save money. An unidentified woman working on a ranch is pictured here. (ARC.)

For generations, children have been an important component of ranch operations. They provide unpaid labor and often begin outside chores like milking cows, feeding chickens, or weeding the family garden at an early age. They can also be a big help at brandings and during calving. In the past, it was not uncommon for a 10-year-old child to drive a large piece of haying equipment. Many ranchers believe that a ranch is the best place to raise children. (ARC.)

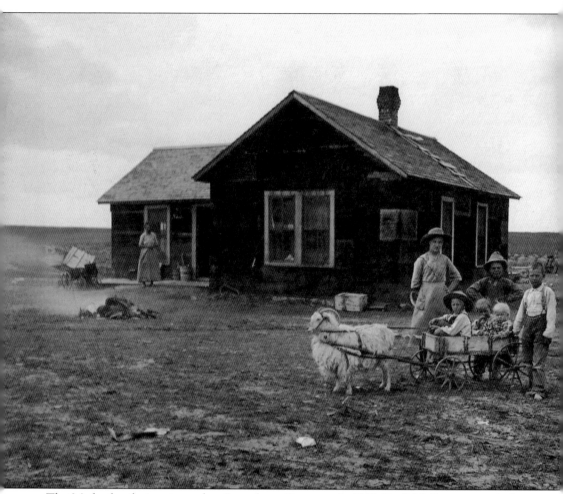

The Meike family immigrated to Iowa from Germany in 1867. Emil Meike grew up in Iowa, Nebraska, and Colorado and eventually toured Wyoming on horseback looking for a way to beat the drought. He and partner H.W. Davis, a rancher in Sussex, Wyoming, decided to form a company to build and run a 20-mile canal to provide water from Kaycee to Sussex. By 1910, water flowed from Powder River through the canal. The Meike family homesteaded in the area. Emil's wife, Emma, is seen here around 1912 with her six children in front of the homestead house. (ARC.)

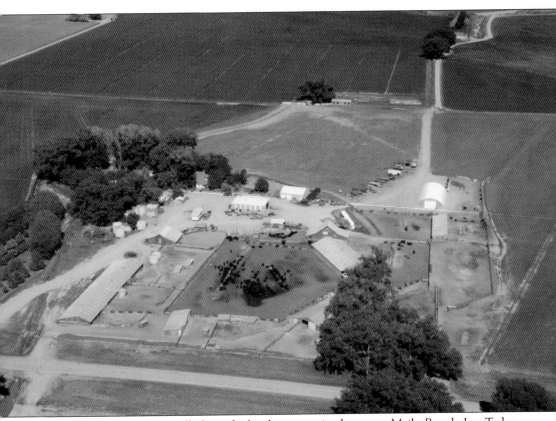

The Meike descendants eventually formed a family corporation known as Meike Ranch, Inc. Today, brothers Don and Peto Meike raise cattle and sheep on their 40,000 irrigated acres, comprised of deeded and leased land. This aerial photograph shows the ranch headquarters. (SHPO.)

The Goodrich Farm, located in Wheatland, still has its cement barn, with intact horse stalls, from 1895. Ward Goodrich, son of founders Gustavus and Rose Goodrich, graduated from the University of Wyoming and served in World War I. He is pictured below in the 1920s with feeder lambs. After the war, Ward returned to the farm, where he planted sugar beets and bought lambs he fed on the farm's feedlot. Ward built the farmhouse where members of the Goodrich family still live. The family survived the Depression by growing their own food and raising chickens and milk cows. They supplied chickens throughout the United States from their 5,000 egg incubators. Ward Goodrich was an innovator and owned the first tractor in the area. (Above, RC; below, SHPO.)

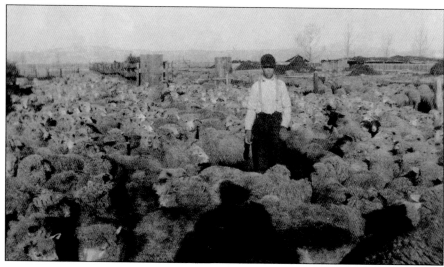

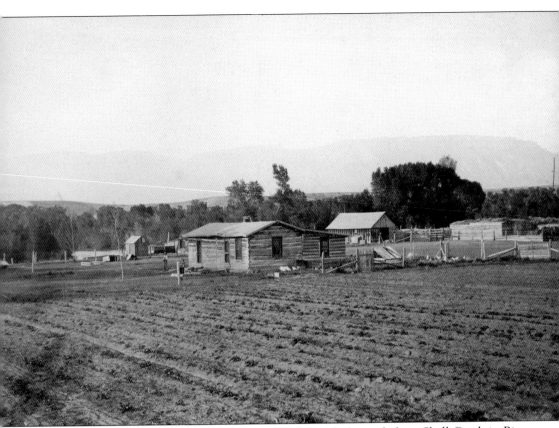

Arthur and Anna Flitner bought the Diamond Tail Ranch, located along Shell Creek in Big Horn County, in 1906 from W.W. Leavitt for $9,140. The ranch included 160 acres of land, 160 head of cattle, and four work horses. The property also came with a sturdy house and a little log building that still stands at the ranch headquarters today. (SHPO.)

Arthur and Anna Flitner's son Howard joined the family business in 1924, added acreage to the ranch, and introduced sheep to the operation. Today, the children and grandchildren of Howard and his wife, Maureen, continue to run the ranch. They raise Black Angus cattle and American Quarter Horses on the ranch, which is now over 100 years old. (SHPO.)

John Cheesbrough started the EY Ranch in 1906 after buying the Ivan Ranch on Elk Mountain in Carbon County. He acquired multiple homesteads in the area. His grandson Rod Johnson grew up on the ranch in the 1940s and recalled that the family only went to town twice a year for supplies. Like many ranch kids, the nine-year-old Johnson helped herd sheep and ran the rake during haying season. The ranch had a blacksmith shop, a root cellar, and an icehouse, where the ice cut from the ponds in the winter cooled their food until midsummer. Johnson took over the ranch in 1986. His mother, Victoria, is shown at right running the buck rake during haying season in 1925. The family's sheep herd is pictured below in 1942. (Both, SHPO.)

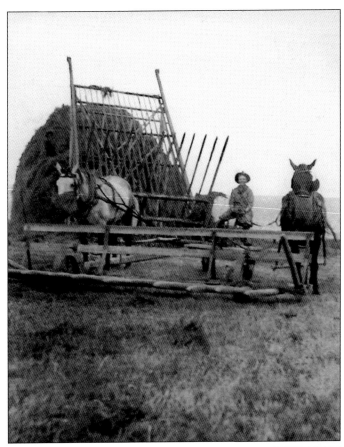

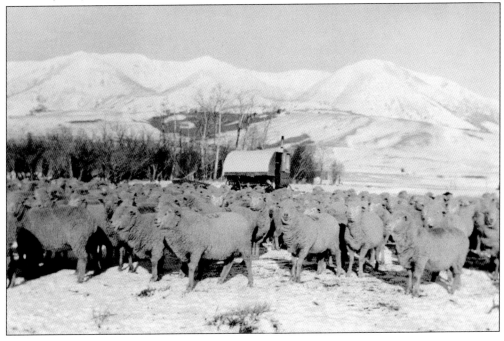

In 1910, Thomas and Estella Livingston bought an 800-acre ranch located south of Sundance in Crook County for $12 an acre. They went into sheep ranching in 1919, in addition to raising cattle, hogs, and chickens and growing oats, wheat, and hay. Thomas and his children also added to the ranch by homesteading. He is pictured here with pigs, which were often raised on ranches for food. His grandchildren raise cattle on the ranch today. (SHPO.)

Charles Henry "Dad" Worland's first home was a dugout built in 1900 near the town that now bears his name. Born in Missouri in 1844, Worland lived in Northern California and Nevada from 1886 to the late 1890s. He trailed sheep along the Oregon Trail to eastern markets and spent one winter in Wyoming's Big Horn Basin, where he settled around 1898. This photograph shows part of the ranch complex. (RC.)

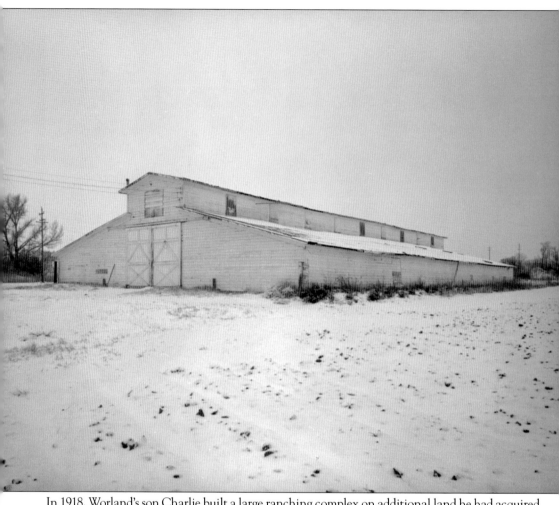

In 1918, Worland's son Charlie built a large ranching complex on additional land he had acquired for the sheep operation. The large lambing shed, constructed in 1918, is shown here. Although the Worland Ranch was sold in 1920, it has always been a working family ranch. (RC.)

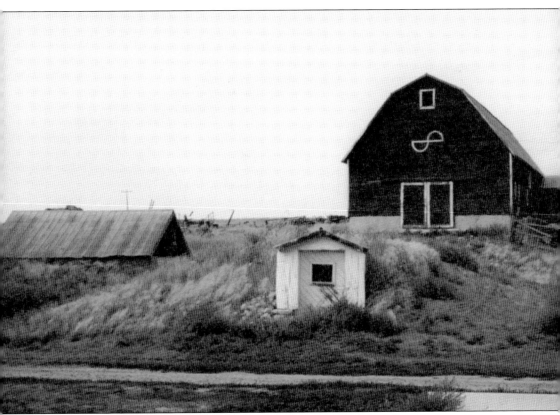

German and Russian by birth, Heinrich Amend filed on a homestead in Goshen County in 1908. He added land over the years to create the Lost Springs Ranch. His son Hank helped on the ranch before he bought his own place. Like many others during the hard times of the 1930s, Hank also worked in the oil fields of Utah, Colorado, and Wyoming to make ends meet. He and his wife eventually acquired his father's nearby ranch. Heinrich Amend's descendants continue to live on the ranch. The original Lost Springs Ranch barn, built in 1918, is featured in this photograph. (SHPO.)

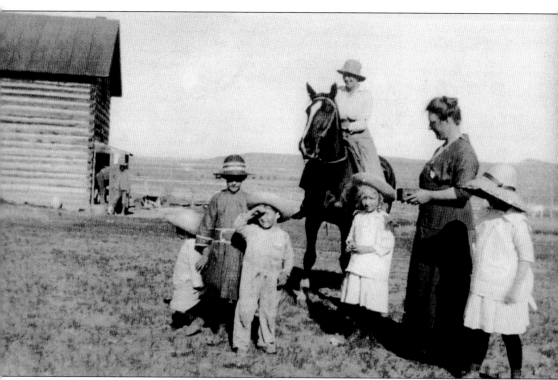

Ohio-born Albert Sommers settled near the town of Opal in 1907, where he taught school. He filed on a homestead along the Green River in present-day Sublette County. Sommers married another homesteader, May McAlister, in 1911. The Sommerses held outside jobs so they could build the ranch. May taught school for nearly 50 years in order to support their four children and the ranch after Albert's death at age 59. May Sommers is pictured here with her young children and a friend. The unusual two-story house in the background is seen before it was renovated for educational purposes. (SHPO.)

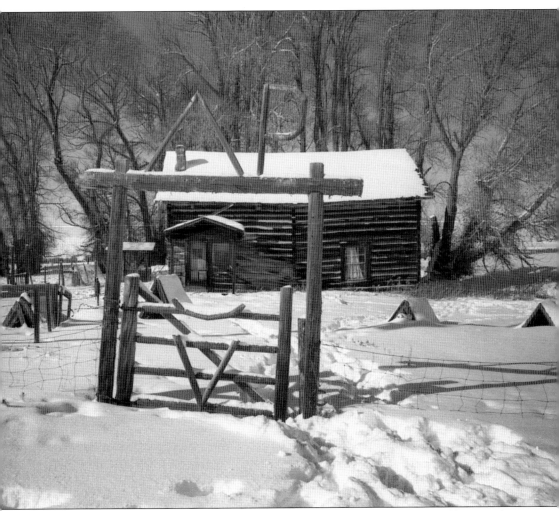

Two Sommers grandchildren have donated a number of original headquarters buildings to the local historical society to be used as a living history/interpretive site. The ranch's brand, made from wood, is seen above the gate leading to the ranch house. (RC.)

The
Ranchman's Reminder

DEVOTED TO THE
THEORY AND PRACTICE OF ARID AGRICULTURE

Entered February 17, 1904, at Laramie, Wyoming, as Second Class Matter, under Act of Congress of July 16, 1894.

| VOL. VI. | SEPTEMBER, 1909 | NO. 9 |

Ode to Irrigation.

(Sung at the opening session of every National Irrigation Congress.)

O, Des-ert Land! O, Des-ert Land!
The land of the smiting sunglare, deep-blue of the star-pierced night,
Of rock-piled heights and chasms,
Awe-fraught to the dizz'-ing sight,
Where the shadow ever chasing the light of the blinding day
With purple and pink and crimson,
With purple and pink and crimson,
Opalescent and far away!
The candlesticks of the cactus, flame-torches here uphold;
Sun flower disks and feath'ry mustard spread fields of the cloth of gold.
The polished cups of amole are girded with spears of thorn,
When the desert wind rises, and they fade as they were born,
And they fade as they were born.
The rainbow colored spaces wan and withered in a breath;
Bones of man and beast lie together under mirage-mock of death.

CHORUS.
Life of sky and sand awakening to prey,
When all is done;
Life of sky and sand awakening to prey
When all is done;
Land of the desolate, desolate people,
Land of the desolate, desolate people,
Land of the desolate, desolate people,
Born of Sirocco and sun!
O, Desert Land! O, Desert Land!

| 5c PER COPY | 25c PER YEAR | LARAMIE, - WYOMING |

PUBLISHED MONTHLY BY THE
AGRICULTURAL COLLEGE AND EXPERIMENT STATION
OF THE UNIVERSITY OF WYOMING

The Agricultural College of the University of Wyoming distributed *The Ranchman's Reminder* to ranchers and farmers beginning in 1905. The bulletin featured the results of agricultural experiments and research and promoted new agricultural practices. (EDC.)

124

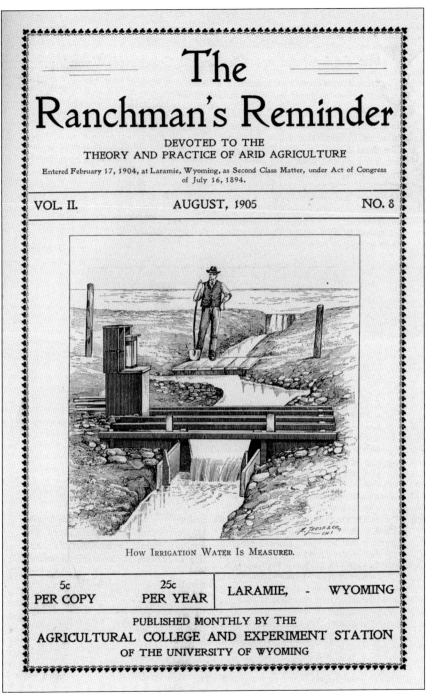

The
Ranchman's Reminder

DEVOTED TO THE
THEORY AND PRACTICE OF ARID AGRICULTURE

Entered February 17, 1904, at Laramie, Wyoming, as Second Class Matter, under Act of Congress
of July 16, 1894.

| VOL. II. | AUGUST, 1905 | NO. 8 |

HOW IRRIGATION WATER IS MEASURED.

| 5c PER COPY | 25c PER YEAR | LARAMIE, - WYOMING |

PUBLISHED MONTHLY BY THE
AGRICULTURAL COLLEGE AND EXPERIMENT STATION
OF THE UNIVERSITY OF WYOMING

The Smith Lever Act of 1914 created agricultural extension offices at land grant universities as another way to modernize the country's livestock and crop production and also included programs aimed at ranch and farm women who were interested in the developing science of home economics as a way to benefit themselves and their families. The cover of the September 1909 *Ranchman's Reminder*, shown here, promoted irrigation, while the August 1906 bulletin on the previous page was devoted to the popular topic of dry farming. (EDC.)

125

Gordon V. Fitzhugh traveled the Texas Trail on eight cattle drives before he finally settled in what later became Converse County in 1874. Jim Fitzhugh and his son Dana, both seen below, represent the third and fourth generation, respectively, and run the small family ranch as a Red Angus cow and calf operation. Like all successful ranchers, they have had to modernize with the times. Technology has radically altered the way the Fitzhughs do business. They consign their cattle to a video auction, and ultrasounds and blood testing are facilitated by computers. Jim Fitzhugh believes that "all ranchers that are left are good operators, or they wouldn't be in business." With continued hard work and luck, the Fitzhughs hope to hand the reins over to the fifth and sixth Fitzhugh generations, who represent the future of ranching in Wyoming. (Both, RC.)

BIBLIOGRAPHY

Abbott, E.C. "Teddy Blue" and Helena Huntington Smith. *We Pointed Them North: Recollections of a Cowpuncher*. Norman: University of Oklahoma Press, 1939.

Brisbin, James S. *The Beef Bonanza; or, How to Get Rich on the Plains*. Norman: University of Oklahoma Press, 1959.

Burroughs, John Rolfe. *Guardian of the Grasslands: The First Hundred Years of the Wyoming Stock Growers Association*. Cheyenne: Pioneer Printing & Stationery Co., 1971.

Cassity, Michael. *Wyoming Will Be Your New Home*. Cheyenne: Wyoming State Historic Preservation Office, 2011.

Clay, John. *My Life on the Range*. Norman: University of Oklahoma Press, 1962.

Dale, Edward Everett. *The Range Cattle Industry*. Norman: University of Oklahoma Press, 1930.

Frink, Maurice. *Cow Country Cavalcade: Eighty Years of the Wyoming Stock Growers Association*. Denver: The Old West Publishing Co., 1954.

Frink, Maurice, W. Turrentine Jackson, and Agnes Wright Spring. *When Grass Was King: Contributions to the Western Range Cattle Industry Study*. Boulder: University of Colorado Press, 1956.

Georgen, Cynde. *One Cowboy's Dream: John B. Kendrick, His Family, Home and Ranching Empire*. Sheridan, WY: Sheridan Printing, 1995.

Hensley, Marcia Meredith. *Staking Her Claim: Women Homesteading the West*. Glendo, WY: High Plains Press, 2008.

Spring, Agnes Wright. *The Cheyenne Club: Mecca of the Aristocrats of the Old-Time Cattle Range*. Kansas City, MO: Don Ornduff, 1961.

Stewart, Elinore Pruitt. *Letters of a Woman Homesteader*. Lincoln: University of Nebraska Press, 1961.

Weidel, Nancy. *Sheepwagon: Home on the Range*. Glendo, WY: High Plains Press, 2001.

Wentworth, Edward. *America's Sheep Trails*. Ames: Iowa State College Press, 1948.

Wyoming Centennial Farm and Ranch Yearbooks. Cheyenne: Wyoming State Parks and Cultural Resources, 2006, 2007, 2008–2009, 2010, 2011, 2012.

DISCOVER THOUSANDS OF LOCAL HISTORY BOOKS
FEATURING MILLIONS OF VINTAGE IMAGES

Arcadia Publishing, the leading local history publisher in the United States, is committed to making history accessible and meaningful through publishing books that celebrate and preserve the heritage of America's people and places.

Find more books like this at
www.arcadiapublishing.com

Search for your hometown history, your old stomping grounds, and even your favorite sports team.

Consistent with our mission to preserve history on a local level, this book was printed in South Carolina on American-made paper and manufactured entirely in the United States. Products carrying the accredited Forest Stewardship Council (FSC) label are printed on 100 percent FSC-certified paper.

MADE IN THE